HISTORIC TALES

from the

TEXAS REPUBLIC

★

A GLIMPSE OF TEXAS PAST

JEFFERY ROBENALT

THE
History
PRESS

Published by The History Press
Charleston, SC 29403
www.historypress.net

Copyright © 2013 by Jeffery Robenalt
All rights reserved

First published 2013
Second printing 2013

Manufactured in the United States

ISBN 978.1.60949.938.9

Library of Congress CIP data applied for.

Contents

CONTENTS

ACKNOWLEDGEMENTS

No author and family man could possibly undertake the project of writing a book without the loving cooperation of an understanding wife and daughter like my Lizabeth and Emily. They held things together at home without interruption or resentment during the many times when my head was buried deep in my laptop and my mind was immersed in old Texas. Without their love and support, this book would have never been a reality. Thanks also to my good friend and church brother Kevin, who was always there to lend a word of encouragement when I most needed it, and to my very best friend Mark, who never stopped believing in my ability to finish this project. I also wish to thank my good friend and historian Donaly Brice for the assistance he provided in acting as a sounding board for many of my ideas. Finally, I wish to thank my editor, Christen Thompson. Her belief in my ability, ongoing patience and invaluable guidance kept me on the right path and enabled me to reach my goal.

INTRODUCTION

Although the history of the Republic of Texas has been chronicled many times over the years, a few of the key individuals and defining moments from its storied past have been seldom touched upon or looked at under a different light. The republic was forged by a cast of outstanding and unforgettable characters whose personalities and penchants committed the Lone Star State to its unique history. The first two presidents, Sam Houston and Mirabeau Lamar, were the driving forces in shaping much of the new nation's brief history. Although both men were united in their love of country and belief in its greatness, they were committed to opposite paths. Surprisingly, the flamboyant warrior Sam Houston chose a peaceful path of negotiation and austerity, while the quiet poet Mirabeau Lamar led by the sword on a free-spending path to glory. Mexican dictator Antonio Lopez de Santa Anna also influenced much of the republic's history. His belief in a strong centralist government led to the Texas revolution, and his refusal to recognize the independence of the new republic after the revolution was the driving force behind many of the actions taken by Houston and Lamar. Stephen F. Austin, the "Father of His Country," was a calming influence in troubled times, and his early death was a great loss to the new nation. Then there were Captain Jack Hays and his Texas Rangers with their Colt revolvers, still looked upon as a symbol of Texas, and Commodore Edwin Moore of the little-known and seldom-celebrated Texas Navy.

The essays that make up this book are not intended to be a comprehensive history of the republic; rather, they hope to provide the reader with a closer

look at a unique moment in history that he or she may have overlooked. Of course, some of the people and happenings discussed here are well known, like William Barrett Travis and the heroic stand of the defenders at the Alamo. However, they could not have been omitted from any chronicle purporting to tell even a portion of the republic's glorious and checkered past. Other people and events have managed to survive only in the murky shadows of history, but they too deserve their brief moment in the spotlight. From the formation of the new nation to the process that eventually led to its annexation and statehood, the history of the Republic of Texas is one of desperate struggles, tragic failures and unparalleled successes. It is my hope that this book manages to delve into a few of those moments and presents them in both an understanding and entertaining light.

Chapter 1

THE RISING TIDE OF REVOLUTION

Unrest in the Mexican Province of Coahuila y Tejas

Mexico's independence from Spain and the Mexican Constitution of 1824 brought a new wave of immigration to Texas from the United States. Not only did the new settlers have to cope with the usual hardships of beginning life in a strange land, but they also had to adjust to living in a country with a set of customs and laws that were alien to their nature. Some colonists did their best to accept the conditions of settlement established by the Mexican government, such as swearing allegiance to a foreign country and agreeing to adopt Catholicism, but many refused to make sincere efforts to become loyal citizens. Instead, they continued to speak their own language, keep their own religions, establish their own schools and start their own newspapers. Mexican officials began to worry that the colonists from the United States were becoming too independent.

Tensions also began to rise within Mexico over the balance of power between the states and the national government. Like the United States, Mexico was organized into separate states. Moreover, the Mexican Constitution of 1824 was based on the concept of states' rights, wherein the majority of power resided at the state level. Prior to the constitution, the central government in Mexico City held most of the power, and many Mexican leaders felt that it should return there. The centralists who favored a strong central government feared that too many American settlers were moving to Texas and that the combination of a growing Anglo population and a strong government in the state of Coahuila y Tejas might encourage the colonists to seize the province of Tejas and join the United States.

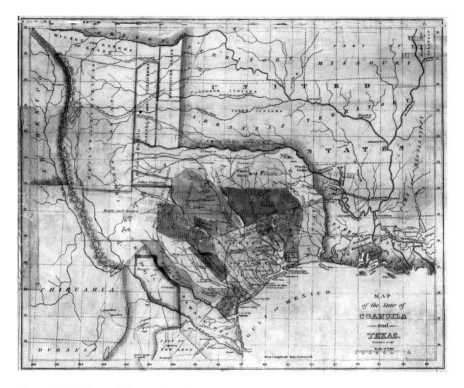

Map of Coahuila and Texas, 1835. Engraved by W. Hooker. *Courtesy of Texas State Library and Archives Commission.*

In 1825, a conflict arose concerning land ownership in empresario Haden Edwards's land grant near Nacogdoches. When Edwards had the land surveyed, he found that many people were already squatting on his grant, including the Cherokees and the descendants of Mexicans who had settled there many years before. All empresarios were required to honor the rights of any settlers they found living on their grants, but unfortunately for Edwards, his was the only grant that had an appreciable number of settlers. Edwards posted notices that the squatters would be evicted from the grant unless they presented proof of legal ownership. Most settlers had no such proof. Instead, they complained to Mexican officials in Saltillo, the capital of Coahuila y Tejas, and Governor Blanco sided with them. Edwards's brother Benjamin wrote a series of angry letters to the governor protesting the decision.

Edwards's problems escalated when he overturned the results of an election for the mayor of Nacogdoches. Most longtime settlers voted for local

resident Samuel Norris, but Edwards handed the election to his son-in-law. In response, a now angry Governor Blanco reversed the election, cancelled Edwards's land grant and issued an order for Haden and Benjamin to leave Texas. The Edwards brothers refused the order and signed an alliance with some of the local Cherokees. Forming the Republic of Fredonia, the rebels declared independence on December 16, 1826. Mexican authorities immediately dispatched soldiers to suppress the rebellion. Stephen F. Austin, who worried that that the actions of the Edwards brothers would reflect poorly on all Texas colonists, joined his militia with the Mexican troops. The conflict ended peacefully in January 1827 when Haden and Benjamin fled Texas before the combined force reached Nacogdoches. Two Cherokees were hanged for their involvement in the episode.

Though the Fredonian Rebellion was quickly stamped out, Mexican centralists remained concerned that the increasing number of American settlers pouring into Texas would lead to an attempted takeover by the United States. This concern was fueled when President John Quincy Adams sent minister to Mexico Joel R. Poinsett to Mexico City with an ill-fated and unsuccessful offer to purchase Texas. Mexican officials, even those who tended to favor states' rights, were offended by the American belief that Mexico would be willing to sell part of its territory.

As a result, in 1828, Mexican authorities sent General Mier y Teran to investigate conditions in Tejas. The general spent nearly a year touring the province and filed a written report upon his return in which he expressed concern over the growing influence of the United States in Texas affairs, stating that Anglo-American colonists now outnumbered Mexican settlers by a ratio of ten to one. He further stated that many of the Anglos ignored Mexican laws, especially the laws regulating trade with the United States, and made it clear that he felt Mexico must regain control of Tejas before it was too late. "I am warning you to take timely measures," he reported. "Texas could throw the whole nation into rebellion."

Citing General Teran's report, nationalist officials persuaded President Vicente Guerrero to abolish slavery in Mexico with the logic that since many of the Anglos owned slaves, the flood of American immigration would slow. However, the centralists realized that simply abolishing slavery would not be sufficient to gain control of the situation. They also enacted the Law of April 6, 1830, banning all immigration from the United States while encouraging Mexican and European immigrants by offering them free land and money for their passage. All empresarial grants not yet fulfilled were canceled. Other provisions of the law banned the importation of slaves, established

new presidios (manned in part by convict soldiers recently dredged from Mexico's prisons) and placed customs duties on all goods entering Texas from the United States. In spite of their intent, these provisions served only to anger the Anglo colonists, who felt ill-treated by the Mexican government.

The law of April 6, 1830, also raised serious political questions within Mexico between the centralists and the federalists, who favored the states' rights approach. Mexican federalists felt that the central government had gone too far. Under the Mexican Constitution of 1824, the provisions of the new law should have been enforced by each separate state in its own way, not by the national government. This approach would have allowed the state of Coahuila y Tejas to administer the law in an evenhanded manner, thus giving the Texas colonists more of a voice in their own affairs. Unfortunately, instead of resolving the growing crisis, the 1830 law served only to increase the level of tension.

General Antonio Lopez de Santa Anna took advantage of the unstable environment within the Mexican government to pose as a proponent of states' rights and launch a revolution against centralist president Anastasio Bustamante. During the revolutionary upheaval in Mexico, disturbances were also occurring in Texas, and General Santa Anna sent Colonel Jose Mexia to conduct an investigation. While he was in Texas, Stephen F. Austin met with Mexia and convinced the colonel that the Texans supported Santa Anna's efforts to preserve the Constitution of 1824. Unfortunately, the Texans would soon learn that Santa Anna was, in fact, a centralist who desired to become dictator of all of Mexico.

The actions of two foreign-born Mexican officials, George Fisher and Colonel John Davis Bradburn, added to the serious unrest among the Texas colonists. Fisher was appointed to collect customs duties and put a stop to the smuggling that was common in Texas. He required all ship captains to receive clearance papers issued from the customhouse at Anahuac on Galveston Bay no matter which port of entry they used. This meant that many captains had to sail past their intended port of entry or make a long overland journey to secure the proper papers. Although most ship captains simply ignored the order, they still perceived Fisher's actions as unnecessary harassment.

Until 1830, the enforcement of many Mexican laws in Texas had been overlooked by the government in order to promote the growth of settlement. However, Colonel John Davis Bradburn was given the unenviable task of enforcing all Mexican laws, including the provisions of the new April 6 law. His haughty manner and strict enforcement methods angered many settlers. Bradburn arrested Francisco Madero, a land commissioner sent by the

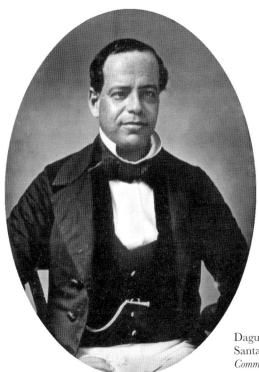

Daguerreotype of Antonio Lopez de Santa Anna, circa 1853. *Wikimedia Commons.*

government of Coahuila y Tejas to issue land titles to settlers living in Tejas. This was a foolish mistake, since the April 6 law only prohibited granting titles to new settlers coming from the United States, not longtime residents of the province. Bradburn also forced the settlers to provide free materials and labor for the construction of a new fort at Anahuac and used their slaves for public works programs.

In May 1832, Louisiana slave owner William Logan arrived in Anahuac from the United States seeking two runaway slaves. When Bradburn refused to release the slaves without proof of ownership, Logan hired attorney William Barrett Travis to represent him and returned to Louisiana for the necessary papers. After Logan's departure, Travis attempted to trick Bradburn into releasing the slaves and was thrown into jail, as was his law partner, Patrick Jack, for protesting Travis's arrest. More than 150 settlers gathered at Anahuac and demanded that Bradburn release the prisoners. He agreed, but only if the Texans would disperse. The settlers pulled back a few miles to Turtle Bayou, but Bradburn still refused to release Travis and Jack.

In response, the settlers sent John Austin to Brazoria to secure a cannon. While they awaited Austin's return, the colonists drafted a statement known as the Turtle Bayou Resolutions. The resolutions stated that the colonists pledged their loyalty to Mexico and supported Santa Anna, whom they believed was in favor of the Constitution of 1824. Before Austin returned to Turtle Bayou, Colonel Piedras, the commander of the Mexican troops at Nacogdoches, arrived in Anahuac. After a brief investigation, he released Travis and Jack and dismissed Bradburn from his command. Unfortunately, Colonel Piedras's actions came too late to prevent bloodshed. Austin and his men had already loaded the cannon onto a small ship at Brazoria and sailed down the Brazos River to Velasco.

Unaware that Travis and Jack had been released, the colonists demanded passage, but Colonel Domingo Ugartechea, the Mexican commander at Velasco, refused. Fighting broke out, and for the first time, the Texans and Mexican soldiers exchanged fire. The Mexicans soon ran low on ammunition and were forced to surrender, but ten Texans and five Mexicans were killed in what became known as the Battle of Velasco. Colonel Ugartechea and the remainder of the Mexican soldiers were ordered to return to Mexico. The Texans continued on to Anahuac, where they learned that the crisis had already been resolved.

In October 1832, fifty-six delegates met in San Felipe to draft a set of resolutions. After they elected Stephen F. Austin president of the convention and pledged support for the Mexican Constitution of 1824, the delegates asked for the repeal of the law of April 6, 1830, better protection from the Native Americans, creation of a public school system and, finally, that the state of Coahuila y Tejas be divided so the Texans would have their own government. At the conclusion of the convention, Stephen F. Austin traveled to the provincial capital of San Antonio, but the right to petition the government was not guaranteed under the Mexican system, and officials refused to send the resolutions to Mexico City.

While Austin was in San Antonio, another convention was called on April 1, 1833, and the members elected Victoria delegate William Wharton to lead the meeting. The delegates adopted many of the same resolutions as the Convention of 1832, but in addition, they also drafted a constitution for the Mexican state of Tejas. Drafting a constitution was a serious step toward independence, and even Mexicans who tended to sympathize with the Texas cause felt that the action was in direct defiance of the government. Stephen F. Austin personally traveled to Mexico City to deliver the Texans' resolutions. The trip took nearly three months, and when Austin reached the

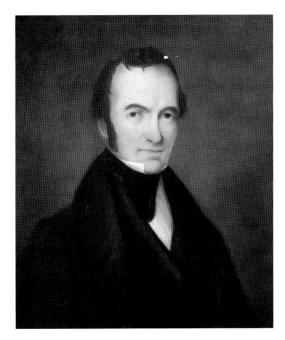

Stephen F. Austin, "The Father of Texas." *Courtesy of Texas State Library and Archives Commission.*

capital in July 1833, he found the city in turmoil after a successful revolution by Santa Anna and a widespread cholera epidemic.

Since President Santa Anna was temporarily out of the capital after successfully concluding his revolution, Austin presented the resolutions to Vice President Valentin Gomez Farias. However, Farias was unwilling to accept responsibility for dealing with such an important issue and was slow to address the Texans' problems. After several weeks, Austin grew impatient, and in October he wrote a letter to the Texas delegates suggesting that they go forward and establish a new state government that would make Tejas separate from Coahuila but still remain loyal to Mexico.

The following month, Austin met with Santa Anna, who unexpectedly agreed to most of the convention's resolutions, though he rejected the request for separate Tejas statehood. Austin left Mexico City on December 10, bound for home, but was arrested when he reached Saltillo. Mexican agents intercepted the letter he wrote to the Texas delegates, and Farias felt that it challenged the authority of the Mexican government. Accused of treason, Austin was imprisoned and eventually held under house arrest for much of the following two years.

Texas remained calm during Stephen F. Austin's long confinement, though tensions between the Mexican government and the Anglo-American

settlers remained high. Then, just before Austin's release in the summer of 1835, new events fanned the flames of unrest. Finally showing his true colors, General Santa Anna dismissed the Mexican congress and had a new constitution written that appointed him dictator of Mexico. In his first action as dictator, he sent his brother-in-law, General Martin Perfecto de Cos, north with sufficient troops and orders to deal harshly with any sign of rebellion in Texas. The stage for total revolution was now set. All that was lacking was a spark to ignite the powder keg.

Chapter 2

THE BATTLE OF GONZALES—"COME AND TAKE IT"

The First Battle of the Revolution

During the first few years of its newly won independence, Mexico followed Spain's policy of strictly limiting Anglo-American settlement in Texas. However, after adopting the Constitution of 1824, the Mexican government liberalized the immigration policy. In 1825, American Green DeWitt received permission to settle four hundred families in central Texas near the confluence of the San Marcos and Guadalupe Rivers. From the inception of Dewitt's colony, the settlers of its capital, Gonzales, were plagued by attacks from both local Native American tribes like the Karankawas and the Tonkawas and the more distant and fierce Comanches.

The attacks continued unabated for more than a year, culminating in the burning of Gonzales. Seeking to bring an end to the violence, DeWitt negotiated a peace treaty with the Karankawas and Tonkawas, and the town was rebuilt. But the Comanches continued to raid the colony on a regular basis. In 1831, the colonists sought help from local Mexican authorities, but with no troops to spare, the only aid the military was able to offer was the loan of one small cannon. Though the tiny six-pounder provided little in the way of defense (other than loud noise and a little smoke), the cannon would play a key role in future events leading to the independence of Texas.

Meanwhile, in Mexico, the states' rights federalists were involved in an ongoing struggle for control of the government with the centralists. In 1833, General Antonio Lopez de Santa Anna seized power. The Texans supported Santa Anna, believing him to be a federalist, but they soon realized that he failed to share their states' rights views on government. Once in power, Santa

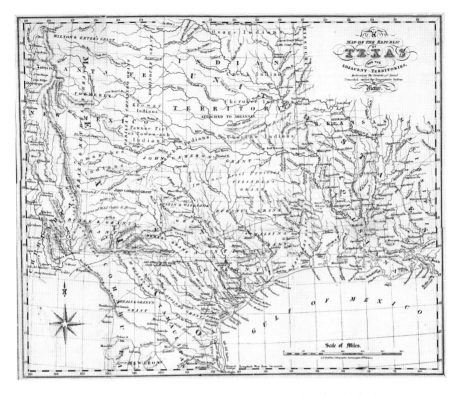

Map of the Republic of Texas and the adjacent territories indicating the land grants conceded under the empresario system of Mexico, 1841. *Courtesy of Texas State Library and Archives Commission.*

Anna displayed his true colors by dismissing the Mexican congress, annulling the Constitution of 1824 and declaring himself dictator of Mexico for life.

Unrest grew throughout Mexico as Santa Anna began to consolidate his power, and in 1835, several Mexican states revolted. The revolts were brutally suppressed. In one instance, the new dictator dissolved the legislature of Coahuila y Tejas and rewarded his troops with two days of rape and pillage in the town of Zacatecas. In June, the political unrest spread to Texas when the first skirmish between Mexican soldiers and Texas settlers took place near Anahuac. However, in spite of the rising tensions, most settlers—like those of Green DeWitt's colony—remained loyal Mexican citizens, although admittedly of the federalist persuasion.

Santa Anna ignored the Texans' loyalty and worsened matters when he sent his brother-in-law, General Martin Perfecto de Cos, and his

troops to Texas. Upon reaching Texas in January 1835, Cos dispatched
Captain Antonio Tenario to Anahuac on Galveston Bay with orders to
establish a customhouse. Captain Tenario's two officers and thirty-four
men encountered many difficulties, including a shortage of boats and
artillery, which made it difficult to put a stop to the smuggling. Tenario
also complained to Cos that local merchants refused to furnish his men
with supplies, leaving the detachment vulnerable to attack from colonists
frustrated by the inconsistent enforcement of customs laws.

In June, Captain Tenario imprisoned Andrew Briscoe and DeWitt C.
Harris for defying customs officials. Growing weary of attempts to negotiate
peacefully, a committee of the War Party led by colonist James Miller met
and authorized revolutionary hothead William B. Travis to expel Tenario
and his men from Anahuac with force if necessary. Travis organized a
company of twenty-five men and sailed from Harrisburg to Anahuac on
the *Ohio*, hoping to arrive before the Mexicans were reinforced. Arriving on
June 29, the Texans fired a single shot before Travis demanded that Captain
Tenario surrender. Initially, Tenario refused, but he quickly surrendered
when Travis ordered an advance on his position. The terms of surrender
included a promise that the Mexican officers would not take up arms against
Texas in the future. Tenario and his men were transported to Harrisburg on
the *Ohio* and later marched to San Antonio de Bexar.

Political opinion remained sharply divided in Texas, and the actions at
Anahuac were later criticized throughout the colony. Settlements favoring
the War Party were stirred up by revolutionary hotbloods, who supported
a move toward rebellion, while others—including Gonzales—supported
the Peace Party and continued to openly declare their loyalty to Mexico.
Leaders across Texas began to call for a meeting to determine the true
majority view. Although many people worried that Santa Anna would
interpret such a gathering as a step toward revolution, by late August, most
settlements agreed to send delegates to a formal Consultation scheduled
for October 15.

On September 10, events began to accelerate when the severe beating of
a Gonzales resident by a Mexican soldier led to widespread public protests.
Fearing a general uprising, Colonel Ugartechea, now commander of the
Mexican garrison at San Antonio, sent a small detachment of soldiers to
Gonzales to retrieve the cannon that had been previously loaned to the
DeWitt colony. When the detachment arrived and requested the return of
the cannon, a poll was taken among the residents of Gonzales by Mayor
Andrew Ponton. The citizens voted overwhelmingly against returning the

cannon and began preparing for trouble by moving their families together, gathering supplies and sending riders across the countryside to gather local militias. They buried the small cannon in a peach orchard for safekeeping.

When the detachment returned to San Antonio empty-handed, Colonel Ugartechea immediately ordered Lieutenant Francisco Casteneda to ride to Gonzales with more than one hundred troops. Instead of requesting the return of the cannon as before, Lieutenant Casteneda was ordered to demand its return. At the same time, he was told to avoid a confrontation if at all possible—extremely difficult orders to follow given the tense situation. Reaching the west bank of the Guadalupe River on the morning of September 30, Casteneda found the river running high from recent rains and all the rafts and barges removed to the east bank, making it impossible to reach the town without a hazardous ford.

Castenada requested to speak with Mayor Ponton but was informed by the armed colonists spread out along the east bank of the river that Ponton was unavailable. After a frustrating day of shouting across the river accomplished nothing, Lieutenant Casteneda moved his men to high ground three hundred yards from the river and set up camp for the night. The following morning, well aware that the size of the Texas force was steadily increasing, Casteneda moved his camp seven miles farther upriver to a more defensible position near a shallow ford. This was in keeping with Colonel Ugartechea's orders to avoid hostile action, but the Texans failed to interpret the move in that light.

Instead, the colonists saw Casteneda's move as a threat, deciding that the Mexican strategy was to either withdraw from Gonzales to await reinforcements or attempt to force a crossing of the Guadalupe at another location. Therefore, they decided to take the initiative and launch their own attack. Once the decision to attack was made, the colonists spent the day readying weapons and equipment, which included digging up the small cannon from the peach orchard and mounting it on a pair of wheels removed from an old cotton wagon. Since there were no cannonballs, cast iron was cut into hunks of shrapnel small enough to fit into the barrel of the cannon.

On the evening of October 1, a force of about 140 Texans under the command of newly elected militia colonel John Henry Moore began to cross the Guadalupe at the Gonzales ferry landing. Once across the river, 50 men on horseback led the way, followed by the cannon. The Texans who were on foot spread out to the flanks and formed a small rear guard. Progress was slow due to the men on foot, and a thick fog that enveloped the Guadalupe River Valley after midnight delayed the march even further. Finally, about 3:00 a.m., the colonists reached the Mexican camp, but a barking dog warned of their approach.

The Mexicans on the perimeter of the camp fired blindly into the fog, but none of the Texans were hit. The loud noise did cause one of the Texans' horses to panic and throw its rider. The man suffered a bloody nose as a result of the fall. After the initial volley, the colonists made a hasty withdrawal, taking cover in a thick stand of timber near the Guadalupe River. Lieutenant Casteneda withdrew his men to a nearby bluff. Between the soupy fog and the early morning darkness, neither force could determine the exact position of the other, so both sides were forced to wait for sunrise.

Fog continued to limit visibility as the Texans finally advanced from the trees about 6:00 a.m. and fired at the Mexicans on the bluff. Casteneda immediately retaliated by launching a counterattack with a small force of cavalry. The Texans again fell back to the trees along the river, where they fired another volley, wounding one of the Mexican cavalrymen. Unable to maneuver among the trees, the Mexican horsemen were forced to withdraw. When the fog began to lift, Lieutenant Casteneda sent a messenger to Colonel Moore requesting a meeting, and the two commanders met in full view of both forces.

Moore explained that the Texans remained faithful to the Constitution of 1824 but could no longer recognize the dictatorship of Santa Anna. It is believed that Casteneda was also a federalist who supported the constitution, but he had no choice other than to follow his orders. Unable to arrive at a compromise, Casteneda and Moore returned to their lines. As Colonel Moore rode in among his men, the Texans fired the small cannon and defiantly raised a homemade flag with the image of a cannon and a star painted in black above the words "Come and Take It." The Texans followed up with a volley from their long rifles, and Colonel Moore led a halfhearted charge toward the bluff. The charge proved unnecessary, as Lieutenant Casteneda, following his orders not to force an engagement, had already begun to withdraw toward San Antonio.

Though the Battle of Gonzales was in reality nothing more than a minor skirmish, the political consequences of the event were far reaching. Like the Battle of Lexington, which initiated the American Revolution, Gonzales served as the Texas "shot heard round the world." Texans had at last taken up arms to defend their rights against Santa Anna's despotism, and they had no intention of turning back. Two days after the battle, Stephen F. Austin, who had long counseled peaceful negotiation until his internment in Mexico, wrote, "War is declared…public opinion has proclaimed it."

The Battle of Gonzales became a magnet for all Texans who bitterly opposed Santa Anna and the dictator's tyrannical policies. Well after the

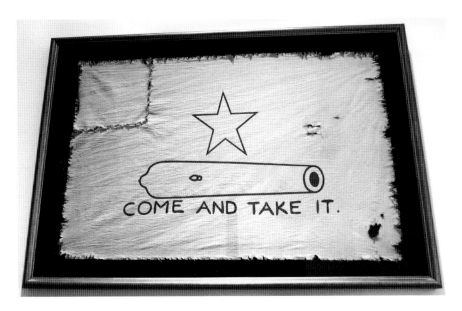

Gonzales Flag—"Come and Take It." *Courtesy of Daniel Mayer, Wikimedia Commons.*

fighting had concluded, angry colonists continued to gather in support of the revolutionary banner. On October 11, Stephen F. Austin, in spite of his lack of formal military training, was unanimously elected commander of the "Army of the People." The following day, the soon-to-be "Father of His Country" led a march to San Antonio that would steadily grow to a force of nearly four hundred men and would eventually culminate in the bloody siege of the Alamo.

Chapter 3

THE BATTLE OF THE ALAMO

A Texas Legend

After the defeat of General Martin Perfecto de Cos at the siege of San Antonio in December 1835, no Mexican troops remained in Texas. Sure that their independence had been won, the majority of volunteers who made up the Army of the People left service and returned to their families. Some members of the provisional government were so confident of victory that they foolishly planned an expedition to capture the Mexican border town of Matamoros. The Texans failed to understand that Mexican dictator Antonio Lopez de Santa Anna was enraged over the capture of Captain Tenorio at Anahuac and the subsequent surrender of General Cos at San Antonio de Bexar.

Determined to reestablish control over Texas, Santa Anna planned to kill or drive out every Anglo and Tejano rebel who openly defied his rule. By the time General Cos reached the Rio Grande on his ignominious retreat from San Antonio, Santa Anna was marching north with a large army. The Texans, blissfully unaware that the Mexican army was on the march, believed Santa Anna would wait until spring. As a result, against the advice of a few men like Sam Houston, the Texans remained unorganized and scattered. To make matters worse, the veterans who had contributed to the victory over General Cos had returned to the comforts of home and hearth. Newly arrived volunteers would constitute the majority of Texas troops in the field. This total lack of preparation would cost the Texans dearly.

In 1836, there were two main invasion routes into Texas from Mexico: the Atascosito Road and the Old San Antonio Road, also known as the Camino

Real. The Atascosito Road crossed the Rio Grande at Matamoros and ran north through Goliad and Victoria before continuing on to the Louisiana border. The Old San Antonio Road crossed the Rio Grande at Eagle Pass and continued northeast to San Antonio and then on to Nacogdoches before entering Louisiana. Colonel James Walker Fannin commanded the Texans who occupied the Presidio La Bahia in Goliad. It was his responsibility to deny the Atascosito Road to the Mexican army. The forces blocking passage on the old San Antonio Road were led by the commander of the Alamo, Colonel James C. Neill.

General Santa Anna divided his forces as he moved north, sending one column under the command of General Jose Urrea up the Atascosito Road and taking personal command of the other column on the long march to San Antonio. The Presidio of La Bahia was well constructed and defensible, but Colonel Neill realized the Alamo would have to be strengthened considerably before it could serve as a fortress. With the assistance of engineer Green B. Jamison, Neill reinforced the crumbling walls of the old mission and replaced a missing section of wall with a log palisade. Twenty-one cannons, most of them captured from General Cos at the siege of San Antonio, were placed along the mission's walls, making the Alamo the most heavily defended fortress in western North America.

Colonel Neill also requested reinforcements for his meager Bexar garrison, but Sam Houston, the commander of the Texas Army, had begun to question the wisdom of maintaining the Alamo. Finally, in mid-January, Houston ordered Colonel James Bowie to ride to San Antonio with a company of volunteers, blow up the old mission and remove all the cannons and munitions to Gonzales. However, when Bowie arrived in Bexar on January 19, he was impressed by the efforts of Neill and Jamison to fortify the Alamo. As a result of their hard work, the old mission was beginning to look like a fortress. Colonel Neill soon convinced Bowie that the Alamo was the only obstacle on the Camino Real that stood between the enemy and the Anglo settlements farther to the east and that it must be defended at all costs.

On February 2, Bowie wrote to Governor Henry Smith that he and Neill had resolved to "die in these ditches" before they would surrender the Alamo. Governor Smith realized that if the Alamo were to function as a blocking position it would have to be reinforced. Colonel Neill would also need cavalry to act as outriders to give early warning of Santa Anna's approach. To meet both needs, Smith directed Lieutenant Colonel William B. Travis to take his "Legion of Cavalry" and report to San Antonio. However, when only thirty men answered Travis's call for duty, he pleaded with Governor

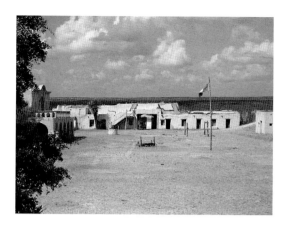

The Alamo Village, an active movie set and tourist attraction north of Brackettville, Texas. *Wikimedia Commons.*

Smith to reconsider his order, threatening to resign his commission rather than stain his reputation with the possibility of failure. Smith wisely ignored the threats, and at length, Travis obeyed the Governor's orders, reporting to Bexar on February 3. Though he reported under duress, Travis, like Bowie, soon became committed to the Alamo as the "key to the defense of Texas."

David Crockett, former congressman from Tennessee, arrived at the Alamo on February 8 with a dozen men eager to win their promised share of Texas, but Colonel Neill was forced to leave soon after due to a family emergency. Neill placed Travis, an officer of the regular Texas Army, in command since James Bowie, though older and more experienced, was only a volunteer officer. The decision did not sit well with Bowie or his men, and they demanded an election of officers, long a tradition among volunteer forces. The decision was split, with the volunteers supporting Bowie and the regulars choosing Travis. After much heated debate, the two men agreed to set aside their differences and share a joint command. Less than two weeks later, Bowie was taken seriously ill and surrendered the command to Travis.

Travis did his best to recruit additional defenders, sending Juan Seguin and James Butler Bonham to Goliad, Gonzales and other communities across Central Texas asking for help. A few men arrived, but never in the numbers required to properly defend the Alamo. Colonel James Fannin, the only source of meaningful reinforcement, was reluctant to abandon his post at Goliad. His constant waffling would eventually lead to the meaningless death of most of his men. On February 23, Santa Anna's troops arrived in Bexar after a brutal winter march across the barren landscape of South Texas, and the thirteen-day siege of the Alamo began. By this time, Travis

had grown desperate for assistance and penned his famous message that has since become the most heroic document in Texas history:

Fellow citizens and compatriots:

I am besieged by a thousand or more Mexicans under Santa Anna. I have sustained a continual bombardment and cannonade for 24 hours and have not lost a man. The enemy has demanded a surrender at discretion, otherwise, the garrison are to be put to the sword, if the fort is taken. I have answered the demand with a cannon shot, and our flag still waves proudly from the walls. I shall never surrender or retreat. Then, I call on you in the name of Liberty, of patriotism & everything dear to the American character, to come to our aid, with all dispatch. The enemy is receiving reinforcements daily and will no doubt increase to three or four thousand in four or five days. If this call is neglected, I am determined to sustain myself as long as possible and die like a soldier who never forgets what is due to his honor & that of his country. Victory or Death.

<div align="right">

William Barrett Travis
Lt. Col. Comdt.

</div>

John William Smith slipped through the Mexican lines and delivered the letter to Gonzales. While unable to bring aid to the beleaguered garrison at the Alamo, the Travis letter did much to motivate the Texan army and was instrumental in rallying American support for the cause of Texas independence.

Why did Santa Anna risk his army by attacking the Alamo instead of bypassing the old mission and marching straight for the heart of the Anglo settlements farther to the east? Such a small garrison would have posed little threat to his rear. Many historians argue that he besieged the Alamo and launched his ill-fated assault for political, not military, reasons. The dictator had promised the Mexican people that he would sweep the rebels out of Texas. If he dared to bypass the fortress, his enemies in Mexico City could claim that he had avoided a fight.

The siege of the Alamo began with an artillery bombardment while the Mexican infantry slowly encircled the old mission. Travis continued to send messages pleading for reinforcements, but the only meaningful assistance to arrive came on March 1, when Lieutenant George C. Kimbell and his thirty-two-man Gonzales ranging company rode through the Mexican cordon

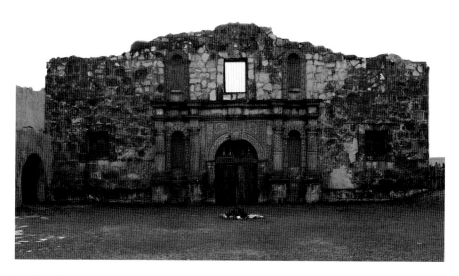

Replica of the Alamo at Alamo Village. *Courtesy of Larry D. Moore, Wikimedia Commons.*

surrounding the Alamo and entered the beleaguered mission. Although he was grateful for the assistance, Travis knew he needed more men if he was to properly defend the Alamo. He revealed his frustration with the lack of support in a letter to a friend: "If my countrymen do not rally to my relief, I am determined to perish in the defense of this place, and my bones shall reproach my country for her neglect."

By March 5, day twelve of the siege, about 1,800 Mexican troops surrounded the Alamo. The walls of the old mission were crumbling from the constant bombardment, and no Texan relief column had appeared. As a warning to the Texans of the fate that awaited them, Santa Anna's soldiers raised the red flag while the band played El Degüello, the cutthroat song and traditional symbol of no quarter. However, Santa Anna's generals argued against a direct assault. Why risk the casualties that would surely result from the Texans' artillery and their accurate rifle fire? Soon the walls would be down anyway and the Texans would be forced to surrender. Determined to make an example of the rebels, Santa Anna ignored these reasonable objections and ordered an attack for dawn on the morning of March 6.

The exhausted Texans were sleeping when the blare of Mexican bugles launched the final assault. In his diary, Mexican colonel Jose Enrique de la Pena described the beginning of the epic battle: "A bugle call to attention

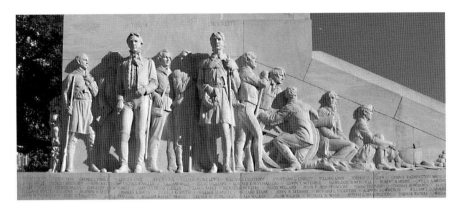

Cenotaph of the Alamo defenders at San Antonio, Texas. *Wikimedia Commons.*

was the agreed signal, and we soon heard that terrible bugle call of death." Awakened by the cry "The Mexicans are coming!" Travis leapt from his bed and ran to the north wall. He was among the first defenders to die. Texas cannons roared their defiance, with canister shot ripping great holes in the oncoming Mexican lines, but their overwhelming numbers enabled the Mexicans to reach the Alamo's walls in spite of the deadly artillery fire and the constant barking of the Texas long rifles.

Bravely scrambling up the scaling ladders into the face of direct fire, the Mexicans burst through the Texas defenses on the walls and poured into the Alamo, their bayonets eager and ready to deal death. Deadly hand-to-hand fighting raged throughout the old mission—bayonets against Bowie knives and rifles used as clubs. Jim Bowie was killed on his sickbed, though some historians credit him with fighting even there. By eight o'clock in the morning, not much more than ninety minutes after the attack began, resistance ceased. The bodies of hundreds of soldiers—Texan and Mexican alike—lay intermingled in bloody heaps all across the compound.

There is no exact count of the casualties suffered during the Battle of the Alamo. Most historians hold the number at 189 defenders and about 600 Mexican soldiers. Legend has it that Crockett died fighting as one of the last defenders. However, Jose Enrique de la Pena wrote in his diary that the former congressman and six others were put to death by order of Santa Anna after they attempted to surrender. Not all the defenders of the Alamo were Anglo-Americans. Nine Tejano defenders also bravely gave their lives for the cause of Texas independence. Among those spared was Susanna Dickenson, widow of artillery commander Almeron Dickenson, the couple's fifteen-month-old

daughter, Angelina, and William Travis's slave Joe. Santa Anna ordered them released in hopes that they would spread fear across Texas.

The heroic stand at the Alamo accomplished little of military value. Some have claimed that it provided Sam Houston with the time he needed to raise and begin to train an army, but Houston spent most of his time during the thirteen-day siege at Washington-on-the-Brazos participating in the Convention of 1836. However, the sacrifice of the gallant defenders of the Alamo did serve to unite the Texans behind the idea of independence and kindled the righteous wrath of "Remember the Alamo." Perhaps even more importantly, the delay allowed the Texans time to form a government and declare their independence—both necessary steps before any nation would recognize Texas. Had Santa Anna been permitted to advance straight into the heart of the eastern settlements, he may well have disrupted the proceedings at Washington-on-the-Brazos and driven the rebels into Louisiana before the government was formed.

A DECLARATION OF INDEPENDENCE AND THE TEXAS CONSTITUTION

The Birth of a New Nation

O n October 2, 1835, the Battle of Gonzales began the military phase of the Texas Revolution; however, a meeting of delegates known as the Consultation gave birth to the true political struggle. The delegates to the Consultation gathered at San Felipe de Austin on November 4, 1835, to determine the course of action that Texas should follow. Delegates who were members of the War Party urged an immediate vote for independence from the tyranny of Santa Anna, while members of the Peace Party preached caution, insisting that Texas remain loyal to Mexico as long as the government returned to the protections provided by the Mexican Constitution of 1824. A vote to decide the matter was held on November 6, with the peace delegates carrying the day thirty-three to fifteen.

The following day, delegates to the Consultation adopted the Declaration of the People of Texas in General Convention Assembled, which stated that, in spite of the initial hostilities, Texans continued to be loyal citizens of Mexico. They also declared that they had fought only to protect themselves and in support of the Constitution of 1824. Finally, the delegates set up a provisional government with Henry Smith as governor and requested that Stephen F. Austin, William Wharton and Branch T. Archer depart on a mission to the United States for the purpose of raising troops and money. The Consultation then agreed to meet again on March 1, 1836, to render a final decision on the question of Texas Independence.

Though as yet unknown to the delegates, by the time the Convention of 1836 convened at Washington-on-the-Brazos on March 1, the desperate

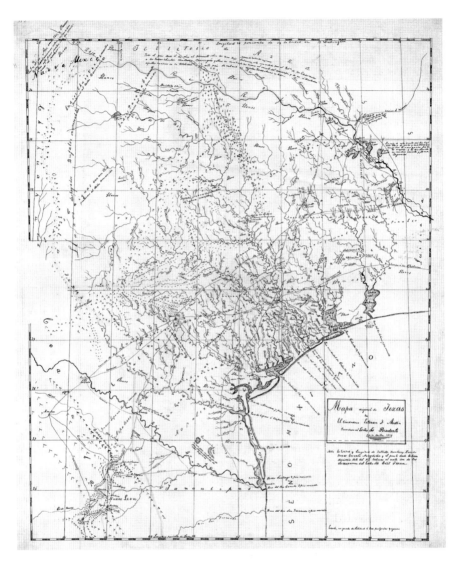

"Mapa Original de Texas," 1829. Drawn by Stephen F. Austin. *Courtesy of Texas State Library and Archives Commission.*

struggle at the Alamo had already begun. Previously, members of the Consultation had wavered on the question of independence, but the delegates to the convention were younger, more recent arrivals to Texas and thus much more likely to support the movement to a free and sovereign state. In addition, Stephen F. Austin, a longtime proponent of peace, had recently

returned from a year of imprisonment in Mexico with a different outlook on the situation. Austin now urged Texans to take action. "War is our only recourse," he stated. "There is no other remedy. We must defend our rights, ourselves, and our country by force of arms."

Forty-four delegates came together on the first day of the convention in near-freezing weather in an unfinished house owned by Noah Byars and Peter Mercer that was so new its fresh timber oozed sap. An observer of the convention visiting Texas on business, Virginia lawyer William Fairfax Gray, recorded his impressions in his diary. Gray described the building as "an unfinished house, without doors or window glass. Cotton cloth was stretched across the windows, which partially excluded the cold wind." The visiting lawyer went on to note that Washington-on-the-Brazos was "a damp and dismal place to conduct such a meeting. The one street was ankle-deep in mud, and the chilling rain left the delegates dispirited."

Fifty-nine members would eventually make up the body of the delegation, with the last delegate, Andrew Briscoe, not arriving until March 11. The delegates were natives of eleven states, mostly from the South, and five foreign countries. Several had political experience at either the state or national level. With Stephen F. Austin in the United States, the only delegate who stirred the imagination of the convention was the former governor of Tennessee, Sam Houston. In his diary, William Gray wrote that Houston's arrival "created more sensation than that of any other man. He is much broken in appearance but has still a fine person and courtly manners." Weeks of travel and a bout of malaria had worn Houston down.

After an examination of the delegates' credentials and the election of officers, a resolution was introduced for the appointment of a committee to draft a declaration of independence. The newly elected convention president, Richard Ellis, assigned the duty to George C. Childress, James Gaines, Edward Conrad, Collin McKinney and Bailey Hardeman. Childress was appointed chairman of the committee. It is generally accepted that he drafted the declaration with little help from the other members. In fact, there is evidence that Childress came to the convention with a draft already prepared. The evidence is substantiated by the fact that Childress presented the declaration to the convention within twenty-four hours of accepting the responsibility.

The delegates reconvened the following day, March 2, and George Childress reported and read a proposed final draft of the declaration. Sam Houston moved for immediate adoption of the proposed document. The declaration was then approved by unanimous vote and signed by all

members present. Like the United States Declaration of Independence written by Thomas Jefferson sixty years earlier, the Texas declaration had three main sections. The first section declared the right of revolution "when a government has ceased to protect the lives, liberty, and property of the people, from whom its legitimate powers are derived."

The second section of the declaration listed the grievances against the Mexican government. The initial grievance stated that General Santa Anna had usurped the Constitution of 1824 and changed it into "a consolidated central military despotism." Another grievance complained that the Mexican government had "invited and induced the Anglo-American population of Texas to colonize its wilderness under the pledged faith of a written constitution" but then reneged on the promise. Other grievances listed by the delegates included "sacrificing our welfare to the state of Coahuila," the arrest of Stephen F. Austin, failure to establish a public education system, military occupation and the denial of such rights as trial by jury and freedom of religion. The third section proclaimed Texas independence and pledged the support of all the delegates who had signed the document.

After the declaration was signed, five copies were dispatched to the designated Texas towns of Bexar, Goliad, Nacogdoches, Brazoria and San Felipe de Austin. Robert Potter then put forward a resolution to form a committee for the purpose of drafting a constitution, and the committee immediately set to work. That evening, a dispatch from William Barrett Travis arrived from the Alamo reporting a minor skirmish with Mexican troops. At first, the message caused consternation among the delegates; however, Gray later wrote in his diary, "Colonel James Fannin is reported to be on the march from Goliad with 350 men for the aid of Travis. It is believed the Alamo is safe."

Drawing on their experience as both United States and Mexican citizens, the members of the committee created a republican form of government, and the new nation became known as the Republic of Texas. In drafting the constitution, the ever-present threat of an attack by Mexican cavalry made the necessity of haste imperative; therefore, the delegates naturally leaned heavily on the United States Constitution as a model to ease their burden. This produced a document that embodied features familiar to Americans. Like its United States counterpart, the republic's constitution was brief in the extreme, with fewer than 6,500 words, and granted the chief executive a wide range of powers.

Other familiarities with the U.S. Constitution included a brief preamble; separation of government power into legislative, judicial and executive

branches, which provided for checks and balances; a bill of rights; male suffrage; slavery; and citizenship—with Africans, descendants of Africans and Indians excepted and a means of amendment. In concert with the U.S. Congress, the Texas legislature was bicameral, with a senate and a House of Representatives, and the executive was also similar to the U.S. presidency in most respects. The judicial system created by the committee was four-tiered, with justice, county, district and supreme courts.

Some of the constitution's atypical provisions, such as declaring ministers and priests ineligible to hold public office, abolishing imprisonment for debt and the prohibition of monopolies, primogeniture and entailment, reflected Jacksonian theories of government. Other provisions unfamiliar to the U.S. Constitution that were adopted from Spanish and Mexican law included community property, homestead exemptions and debtor relief. The process of amending the constitution was also made complex and burdensome, perhaps intentionally so. Amendments proposed in one session of congress were referred to the next session for a second approval and then submitted to a popular vote.

On March 4, Sam Houston was elected commander-in-chief of both the regular and volunteer Texas armies. On the following Sunday, William Gray wrote in his diary, "A dispatch was received from Travis, dated Alamo, March 3, 1836. The members of the Convention and the citizens all crowded into the Convention room to hear it read." The message from Travis was a desperate plea: "We have contended for ten days against an enemy whose numbers are variously estimated from fifteen hundred to six thousand men. I hope your honorable body will hasten on reinforcements, ammunitions and provisions to our aid as soon as possible. God and Texas—Victory or Death."

The members of the convention had no way of knowing that the defenders of the Alamo were already dead, and the message came close to being the death knell of the convention. Many delegates were ready to abandon their efforts and rush to the defense of the Alamo. One delegate moved that the convention "do immediately adjourn, arm and march to the relief of the Alamo." Gray noted in his diary that "a great many persons are preparing to start to the scenes of fighting." Thankfully, Sam Houston, the delegate with the greatest influence due to his extensive military and political experience, knew that such a move would lead to disaster. The one overriding priority had to be the establishment of a legitimate government.

When Houston came to his feet in the midst of the near hysteria that hung like a dark storm cloud over the stifling confines of the crowded convention room, the calm, measured tones of his voice held the delegates in silence. He began

by stating that it was of utmost importance that the delegates complete their task of forming the government. Without a legitimate government to present to the world, there would be no chance of recognition by the United States, let alone other foreign governments, and the Texas Revolution would be doomed from the start. Houston went on to state that, as commander-in-chief, he would immediately depart for Gonzales and rally a force to come to the aid of the Alamo. With that, he strode from the room, mounted his horse and galloped out of town, accompanied by his aide, Colonel George W. Hockley.

Though eventually pressured by word that the Alamo had fallen and that Santa Anna's army would soon be on the march, the delegates to the Convention of 1836 continued at their sacred task and finished the new republic's constitution at midnight on March 16. Since the outcome of the Texas Revolution was still in serious doubt, the final task of the delegates was to establish an ad interim government until such time as formal elections could be held.

David G. Burnet was elected to the office of provisional president. He was a dark, grim man without humor who carried a pistol in one pocket of his tight black coat and a bible in the other. The forty-seven-year-old Burnet was from New Jersey and had traveled the world before arriving in Texas in 1826 to start his own colony. Like his friend Stephen F. Austin, Burnet strongly disapproved

of liquor and profanity, and also like Austin, he despised the hard-drinking and hard-swearing Sam Houston. Houston returned the favor by nicknaming the stern little man "Wetumpka," which Sam laughingly said was Cherokee for hog thief.

David G. Burnet, ad interim president of the Republic of Texas. *Wikimedia Commons.*

Secretary of War Thomas Jefferson Rusk. *Wikimedia Commons.*

Lorenzo de Zavala was selected as the new republic's ad interim vice-president. He was born in the Yucatan peninsula and had helped write the Mexican Constitution of 1824. Zavala remained a loyal Mexican citizen until he fled to Texas and championed the Texan cause when Santa Anna became dictator of Mexico. Other ad interim officers were Samuel P. Carson as secretary of state; David Thomas as attorney general; Thomas J. Rusk, who ultimately served as the liaison between Houston's army and the new government, as secretary of war; and Robert Potter as secretary of the navy.

President Burnet and the other provisional officers had barely assumed their government offices when a report reached Washington-on-the-Brazos that Mexican troops had occupied Bastrop, only sixty miles distant. The news quickly spread panic among the delegates as it already had in the population at large. The infamous "Runaway Scrape," a mass exodus of Texas settlers toward the safety of the Sabine River, was well underway. President Burnet and his provisional government immediately fled seventy miles eastward to the settlement of Harrisburg on Buffalo Bayou. Although it could not be said that all was well in the newly established republic, the efforts of the delegates at the Convention of 1836 had given birth to a new nation.

Chapter 5

THE MASSACRE AT GOLIAD

A Texas Tragedy

The tragedy that was Goliad had its roots in the Tampico Expedition of November 15, 1835, when General Jose Antonio Mexia attacked Tampico, Mexico, with three companies of troops who had enlisted for service at New Orleans. The attack was unsuccessful, and most of the men were captured the next day by Santa Anna's troops. Twenty-eight members of the expedition (the majority Americans) were tried as pirates, convicted and executed by firing squad. On the whole, the reaction to the Tampico executions in the United States was that Mexico had acted within its rights. The lack of protests to the executions led Santa Anna to believe he had found an effective deterrent to the Americans whom he expected would soon flock to the assistance of Texas. At his urging, the Mexican Congress passed the Decree of December 30, 1835, which directed that all foreigners taken in arms against the government of Mexico should be treated as pirates and executed.

Santa Anna's army took no prisoners at the Alamo. It was left to General Jose Urrea, commander of the Mexican forces advancing into Texas from Matamoros, to take action on the murderous decree. Urrea was first faced with enforcing the decree when his troops captured the survivors of Francis W. Johnson's party at the Battle of San Patricio on February 27, 1836. When he reported the prisoners to Santa Anna, the dictator ordered him to carry out the decree. Although reluctant, Urrea issued the order to execute the prisoners. However, when a priest of the local Irish colonists, Father Thomas Malloy, interceded on behalf of the condemned men, Urrea relented and

sent the prisoners to Matamoros for disposition, thus washing his hands of their fate.

General Urrea's respite was short-lived. On March 15, he was again confronted with the dilemma of enforcing the fatal decree at Refugio when his troops captured thirty-three Americans at the Nuestra Senora del Refugio mission. Half of the prisoners were members of Captain Amon B. King's company. King and his men angered local citizens by burning several ranches and killing eight innocent Mexicans sitting around a campfire. The local citizens made General Urrea's decision much easier by demanding justice. He executed King and fourteen of his men more for their murderous acts than to satisfy the decree and released the others. The Mexican advance continued until Urrea's scouts reported that the Texans were occupying Presidio La Bahia at Goliad.

Sam Houston, the commander of the Texas Army, ordered Colonel James Walker Fannin to abandon Goliad and retreat to Victoria on March 11, but Fannin hesitated to await word from Captain King, whom he had sent to Refugio with substantial forces. Though he learned of King's fate on March 17, Fannin failed to order a retreat until the following day. The Texans finally withdrew under the cover of a heavy fog on the morning of March 19. Fannin insisted on taking nine artillery pieces and one thousand extra muskets on the march, slowing the pace considerably. Urrea was unaware of Fannin's departure until two hours later, but the Texans had wasted an hour of their lead struggling with the largest cannon while crossing the San Antonio River.

A mile past Manahuilla Creek, Fannin frittered another precious hour away by ordering a halt in the middle of the prairie to rest the oxen and give them an opportunity to graze. Most of his officers protested the stop, arguing that the column should forge ahead until they reached the protection of the trees along Coleto Creek. Fannin chose to ignore their counsel. Since the fight at Mission Concepçion before the siege of San Antonio, Fannin had held the Mexican army in contempt. He was convinced Urrea would not dare give chase. The Texans had barely resumed the march when a supply cart broke down. While the supplies were transferred to another cart, Fannin sent a party to scout ahead. As the Texans advanced, a troop of Mexican cavalry emerged from the trees along Coleto Creek.

Fannin immediately formed his men and artillery into a moving square and advanced on the Mexican horsemen, but the heavily laden ammunition cart broke down. A hurried council was called to determine the feasibility of taking as much ammunition as they could carry and continuing the advance,

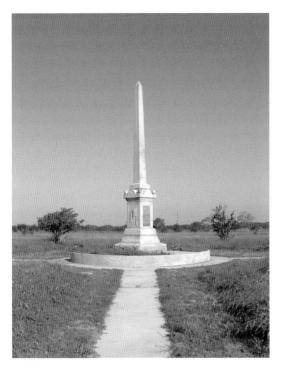

Battle of Coleto Monument at Fannin Battleground State Historic Site, Fannin, Texas. *Wikimedia Commons.*

but General Urrea took note of the confusion among the Texans and launched an attack. Cut off in the middle of the open prairie with little water and much of their vision obscured by tall grass, there was little for the Texans to do but stand ready to receive the Mexican attack. They quickly formed a hollow square three ranks deep with artillery placed at the corners. Each man was issued three or four muskets. Bayonets, pistols and ammunition were also abundant. The Mexican attack was simultaneously launched against all four sides of the square, and the fighting raged until sunset.

During the night, the lack of water and the inability to light fires to treat the wounded drove Fannin's situation to a critical point. An intermittent cold rain and the cries and moans of the wounded added to the misery and demoralized the Texans. A council of officers discussed escape, but the idea was rejected when the men voted unanimously not to abandon the wounded. All that remained was to dig trenches and erect barricades of carts and dead animals. However, by the time this was accomplished, General Urrea had been reinforced with fresh troops and artillery. At sunrise, the Mexican artillery opened fire in preparation of resuming the attack. The heavy barrage convinced Fannin that further resistance would be futile. After consulting with his officers, he decided to seek honorable terms of surrender and hoped that the Mexicans would honor them.

Terms were drafted seeking to guarantee that the wounded would receive proper treatment and that the men would eventually be paroled to the United States. Unfortunately, General Urrea was bound by Santa Anna's orders and the Decree of December 30. He lacked the authority to accept

any terms other than unconditional surrender. In a face-to-face meeting, Urrea made it clear to Fannin that the fate of the prisoners rested with Santa Anna. He could promise only to intercede on the Texans' behalf. The document of surrender signed by Fannin stated that the Texans surrendered "subject to the disposition of the supreme government." Apparently, this fact was never made clear to the men, as the accounts of several survivors indicate that the Texans were led to believe they were surrendering as prisoners of war.

After the Texans surrendered their arms, the uninjured and slightly wounded marched back to Goliad and were imprisoned in the chapel of the Presidio La Bahia. The wounded prisoners, including Colonel Fannin, returned to Goliad in carts and wagons over the next two days. On March 25, eighty prisoners from the Georgia Battalion, which had surrendered near Dimitt's Landing on the same terms accorded to Fannin's men, were added to the Goliad prisoners. In keeping with his promise to Fannin, General Urrea wrote to Santa Anna from Victoria recommending clemency for the prisoners; however, he never mentioned the surrender terms the Texans had drafted. Santa Anna replied to Urrea's letter by ordering the immediate execution of these "perfidious foreigners." Evidently, the dictator doubted General Urrea's willingness to act as executioner because he also sent a direct order to the "Officer Commanding the Post of Goliad" to carry out the executions.

The order was received by Colonel Jose de la Portilla, whom Urrea had left in charge. Portilla spent a restless night considering his options, but he finally concluded that he had no choice except to obey Santa Anna. He ordered that the prisoners be shot at dawn. As the sun rose on Palm Sunday, March 27, 1836, the prisoners who were able to walk were formed into three groups. The largest group was marched along Bexar Road toward the upper ford on the San Antonio River, another group was led along the Victoria Road toward the lower ford and the final group was marched in the direction of San Patricio. Having been told a variety of lies, the most common of which was that they were to be marched to Matamoros or Copano for sea passage to New Orleans, the prisoners moved quietly and held little suspicion of their fate.

At previously selected locations less than a mile from the presidio, the three groups were halted. The guards on the right side of the columns then countermarched to the join the guards on the left side. At a prearranged signal, the guards raised their muskets and fired on the prisoners from point-blank range. The wounded and dying were bayoneted or clubbed

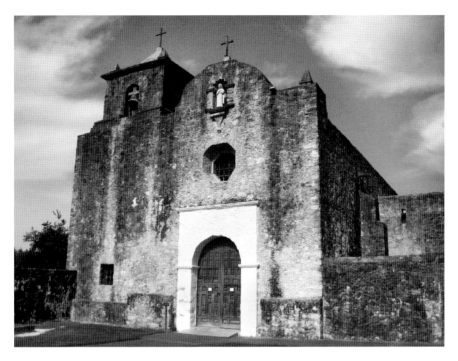

The chapel at Presidio La Bahia, Goliad, Texas. *Courtesy of Travis Witt, Wikimedia Commons.*

to death, while most of those who survived the initial volley were ridden down and lanced by Mexican cavalry. A handful managed to escape. The men wounded in the Battle of Coleto were shot or bayoneted where they lay inside the presidio chapel. After watching helplessly while his men were butchered, Colonel Fannin was the last prisoner to be put to death. Because of his wounded leg, he was taken to the courtyard in front of the chapel, blindfolded and seated in a chair.

Fannin made three final requests: that his personal possessions be sent to his family, that he be shot in the heart and not the face and that he be given a Christian burial. None of the requests was honored, and his body was burned along with the other nearly four hundred Texans who met their fate that day. The remains of the prisoners were left exposed for the vultures and coyotes until June 3, 1836, when General Thomas J. Rusk passed through Goliad in pursuit of a retreating Mexican column. After gathering the remains, Rusk buried them with full military honors. On June 4, 1938, a massive pink granite monument was dedicated on the site as part of the Texas Centennial.

The tragedy at Goliad had a profound effect on the Texas Revolution. Texas as yet had no army, and the new ad interim government was floundering. Moreover, the Texas cause was fully dependent on the generosity and largess of the United States. If Santa Anna had simply dumped the prisoners on American soil penniless and without means of support, the mismanagement and incompetence of the Texas government would have been exposed, Texas prestige would have fallen in American eyes and aid may well have dried up. Instead, the few survivors of the tragedy quickly spread the word, and the massacre at Goliad branded Santa Anna as an inhuman despot and gave the Mexican people—whether deserved or not—a reputation for cruelty. A burning desire for revenge arose among the people of Texas, and Americans were now firmly united behind the Texas cause. Soon the plains of San Jacinto would echo with heroic shouts of "Remember Goliad and Remember the Alamo!"

THE BATTLE OF SAN JACINTO AND THE TREATIES OF VELASCO

Events with Far-Reaching Consequences

Four days after the convention at Washington-on-the-Brazos declared Texas independence, word arrived from Colonel William Barrett Travis of the Alamo's plight. Unaware that the Alamo had already fallen, Sam Houston, the newly appointed commander of the Texas Army, immediately left the convention for Gonzales to organize the troops there and go to Travis's aid. When Houston rode into Gonzales on March 11, he heard from two Tejanos recently arrived from San Antonio that the Alamo had fallen and that its gallant defenders died fighting to the last man. The tragic news was confirmed two days later by Susannah Dickinson, wife of one of the defenders, who was released by General Santa Anna in hopes that she would spread terror across Texas. The dictator's plan met with immediate success.

Panic-stricken, the colonists believed Santa Anna's forces would soon sweep eastward, killing every Texan in their path. Thus began the frightened exodus known to Texas history as the "Runaway Scrape." The people hurriedly gathered their possessions in wagons, carts, on horseback and even on their backs and fled for their lives toward the safety of the Sabine River and refuge in the United States. Houston evacuated Gonzales and burned the town to the ground in the wake of his retreat. The small Texas Army crossed the Colorado River and marched twenty miles down the east bank to Benjamin Beason's crossing near present-day Columbus, where they pitched camp on March 20. Unknown to Houston, Colonel Fannin had surrendered at Goliad, and he and his entire force had been cruelly executed on Palm Sunday at the order of Santa Anna.

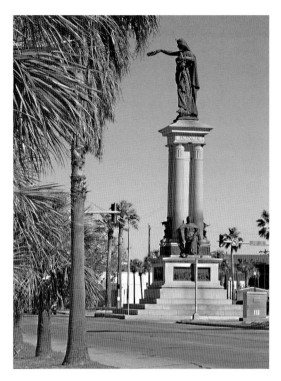

Statue of the heroes of the Texas Revolution by Henry Rosenberg, Galveston, Texas. *Wikimedia Commons.*

When news of the massacre reached the army, Houston's men demanded an immediate attack. How else could they hope to avenge the loss of so many good friends and family at the Alamo and now Goliad? Refusing to justify his decision, Houston ignored their demands and ordered a withdrawal to the Brazos. On March 28, the army arrived at San Felipe de Austin on the west bank of the river and then crossed over and marched to the plantation of Jared Groce, where they set up camp and drilled for two weeks. During this time, the Texas government abandoned Washington-on-the-Brazos and fled to Harrisburg. President Burnet sent Houston a scathing letter demanding that he stand and fight. Burnet also sent Secretary of War Thomas Rusk to convince Houston to take a more aggressive course. Much to the frustration of his army and the government, Houston refused and continued his retreat.

Since Houston appeared unwilling to fight, Santa Anna decided to go after the Texas government. After crossing the Brazos River at Fort Bend near present-day Richmond on April 11, he headed for Harrisburg with seven hundred men, unwisely dividing his forces so that he might move more rapidly. When Santa Anna arrived at Harrisburg on April 15, he learned that the Burnet government had fled from Buffalo Bayou to New Washington (now Morgan's Point). Burning Harrisburg in anger and frustration, the dictator quickly followed, but when he reached New Washington on April 19, he discovered that the government had once again eluded his grasp, this time by ship to Galveston.

Meanwhile, Sam Houston was determined not to fight until he reached ground of his own choosing. Moving his army across the Brazos, he headed

east, burning farms and crops as he marched. There were few towns between San Antonio and the eastern settlements, and when the Mexicans' food and ammunition ran low, Houston intended to make it impossible for them to secure more. This strategy failed to satisfy the Texans, and they continued to grumble their displeasure as the army marched eastward. On April 17, the Texans reached a small settlement known as New Kentucky, where two wagon trails crossed—one trail led to Harrisburg and the other toward the Sabine River. Most of Houston's officers and men believed he would lead the army toward the Sabine and the safety of Louisiana; however, much to the satisfaction of the non-believers, Houston moved the column down the Harrisburg road.

From two prisoners captured by scout Deaf Smith on April 18, Houston learned that the Mexicans had burned Harrisburg and were following the west bank of the San Jacinto River. He also heard that Santa Anna was in command of a column of only seven hundred men and, more importantly, that the Mexicans were forced to cross the bridge over Vince's Bayou and would have to cross the same bridge on their return. After considering the situation, Houston reassured his men that they would soon see action. At dawn on April 20, the Texans arrived at Lynch's Ferry and found it guarded by only a few Mexican soldiers. The Mexicans fled at the sight of the Texans and left behind a flatboat loaded with provisions that had most likely been taken as plunder from Harrisburg. Capturing the provisions was fortunate as the Texans had little supply of their own.

The Texans set up camp along a stretch of rising ground parallel to the bayou and protected by a skirt of timber. The Twin Sisters, two cannons that were gifts from the citizens of Cincinnati, were placed in the center under the command of Colonel Neill. The Mexican camp stood less than a mile from the Texas line. A marsh spread out to the Mexicans' rear, and a temporary breastwork of trunks, baggage and other equipment protected their front. In the early afternoon, a small detachment of Texas cavalry skirmished with some Mexican infantry. In the brief clash, which nearly brought the opponents to open battle, Mirabeau Lamar, a private from Georgia and later president of the Republic of Texas, performed brilliantly and was placed in command of the Texas cavalry.

The morning of Thursday, April 21, dawned bright and clear. Refreshed from a good night's rest and a hearty breakfast of bread made from captured flour and meat from freshly slaughtered cattle, the Texans were eager to launch an attack. They could see the Mexican flags waving in the freshening morning breeze and hear the mournful notes of the enemy's bugle calls.

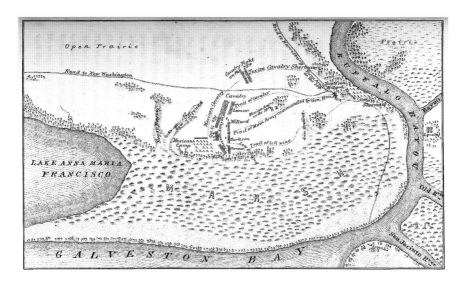

Map of the Battle of San Jacinto, 1836. *Wikimedia Commons.*

A short while later, Deaf Smith rode in and reported that during the early morning, General Cos crossed Vince's Bridge with nearly 600 troops, increasing Santa Anna's strength to more than 1,200. Houston calmly ordered Smith to destroy the bridge to prevent Santa Anna from receiving further reinforcements and to make it impossible for either the Texans or the Mexicans to retreat.

After his plan was approved by Secretary of War Rusk, Houston formed the Texas Army for battle about three thirty in the afternoon. The Texans' movements were screened from the Mexican position by trees and the rising ground that stretched between the positions. All was quiet on the Mexican side during the afternoon siesta, and Santa Anna neglected to post lookouts. The Texans formed their line of battle with Burleson's regiment in the center, Sherman's regiment on the left, the Twin Sisters (under George Hockley) on the right and the infantry under Henry Millard to the right of the artillery. The cavalry under the command of Mirabeau Lamar formed on the extreme right.

At General Houston's command, 910 men advanced silently out of the woods and swept up and over the long rise. Bearded, dirty and ragged the Texans may well have been, but their long rifles were clean and well oiled and their features were set with grim determination. The few musicians began to pipe "Will You Come to the Bower?" a popular love ballad of

the day, and the men bent low as if preparing to face a strong wind. As the troops advanced, Deaf Smith galloped up and informed Houston that Vince's Bridge had been destroyed. The word spread quickly. There would be no retreat. It was victory or death. As the range to the Mexican lines closed, the Twin Sisters moved up and opened fire, sending a blistering load of grapeshot boiling into the enemy barricade.

With the roaring blast of the cannon, the Texans surged forward as one man, screaming, "Remember the Alamo!" and "Remember Goliad!" Blazing away with their long rifles at nearly point-blank range, the raggedy men stormed over the makeshift Mexican barricade, emptied their pistols and went at the Mexicans hand-to-hand, using their rifles as clubs and slashing right and left with their deadly knives. The terrified Mexicans either fell where they stood or fled in panic from the savage fury of the Texas assault. Hysterical pleas of "Me no Alamo!" and "Me no Goliad!" echoed across the battlefield, but there would be no mercy tendered this day. The enraged Texans quickly reloaded their long rifles and went after the fleeing Mexicans, shooting, clubbing or stabbing to death any man they could catch.

The terrorized Mexicans fled into the boggy marshes at the rear of their position, but the bloodthirsty Texans followed them, determined to kill every last man. The water ran red with the blood of the slain. General Houston, his ankle shattered by a Mexican musket ball, did his best to call a halt to the senseless killing, but the fury of the Texans knew no bounds, and the massacre continued. Sheer exhaustion finally brought an end to the slaughter, and Sam Houston rode slowly from the field of victory. At the foot of the oak tree where he had slept the previous night, the commander of the Texas Army slid off his horse and collapsed into the arms of Major Hockley, his chief of staff.

According to the official report of the battle, 630 Mexican soldiers were killed, 208 wounded and 730 taken prisoner. Balanced against this terrible toll, the Texans suffered only 9 killed, most of them in the initial Mexican volley, and 30 wounded. In addition, the Texans captured a large supply of weapons, ample stocks of supplies and $18,000 in silver. Much to Sam Houston's disgust, General Santa Anna disappeared during the battle. The following morning, Houston ordered a search of the surrounding area. That afternoon, Sergeant J.A. Sylvester took note of a Mexican running toward Vince's Bayou. He caught the man hiding in some high grass. The prisoner was dressed in a common soldier's uniform, but when Sylvester took him to the camp, the other prisoners recognized him and cried, "El Presidente!"

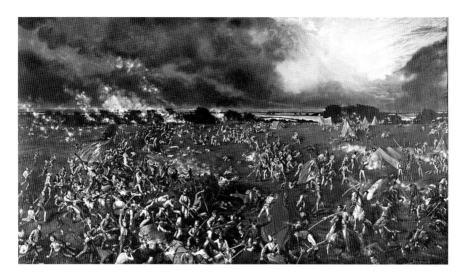

The Battle of San Jacinto by Henry Arthur McArdle. *Courtesy of Texas State Library and Archives.*

"Houston, Santa Anna and Cos." A political cartoon of the surrender of Santa Anna to Sam Houston at the Battle of San Jacinto in 1836. *Courtesy of Library of Congress.*

Santa Anna was brought before General Houston, who was still lying under the oak tree nursing his wounded ankle. Houston made it plain that he despised the dictator, while the Texas soldiers crowded around him, growling angry threats. Terrified, Santa Anna whined, "You can afford to be generous, you have captured the Napoleon of the West." Houston retorted angrily, "What claim have you to mercy when you showed none at the Alamo or at Goliad?" The two men sparred verbally for nearly two hours, but in the end, Santa Anna agreed to write an order commanding all Mexican troops to evacuate Texas. In eighteen glorious minutes, Sam Houston and his Texans had won a remarkable victory, establishing Texas as an independent republic and opening the door for United States expansion south to the Rio Grande and west to the Pacific. Few battles in history have been more decisive or have had more far-reaching consequences than the Battle of San Jacinto.

President Burnet hurried to the battlefield when he got word of the victory and Santa Anna's capture. Sam Houston's staff spoke of the president as "ungracious and hard to please" and often complaining of Houston's use of profanity. The two hardheaded men initially locked horns over the $18,000 in silver coins that had been discovered among Santa Anna's possessions. Burnet demanded that the money be turned over to the republic's treasury, but Houston had already given $3,000 to the Texas Navy and handed out the remainder to his men. Due to a deep distrust of civil government, Santa Anna had also requested that he be permitted to negotiate the upcoming treaty with Sam Houston, but Burnet rejected the dictator's request and transported him to Velasco. It was well that he did. Houston's wound soon grew worse, and he was sent to New Orleans for treatment.

Two treaties were eventually signed by President Burnett and Santa Anna, one open to public scrutiny and the other held secret. The public treaty consisted of ten articles, providing in part that hostilities would cease, Mexico would not again take up arms against Texas, the Mexican army would withdraw beyond the Rio Grande, property confiscated by Mexicans would be restored, prisoners would be exchanged and Santa Anna would be returned to Mexico as soon as possible. The secret treaty consisted of six articles, but the most important article stated that the Texas boundary would not lie south of the Rio Grande.

General Vincente Filisola began the withdrawal of Mexican troops from the Republic of Texas on May 26 in accordance with the terms of the public treaty, but the Texas Army would not allow Santa Anna to be released. On May 20, the government in Mexico City declared all of Santa Anna's actions

The San Jacinto Monument, located at the Battleground State Historic Site in La Porte, Texas, is the world's tallest memorial column at 570 feet. The inscription reads in part: "Measured by its results, San Jacinto was one of the decisive battles of the world. The freedom of Texas from Mexico won here led to annexation and to the Mexican-American War, resulting in the acquisition by the United States of Texas, New Mexico, Arizona, Nevada, California, Utah and parts of Colorado, Wyoming, Kansas, and Oklahoma. Almost one-third of the present area of the American Nation, nearly a million square miles of territory, changed sovereignty." *Wikimedia Commons.*

while he was held prisoner null and void. Thus, the Treaties of Velasco were quickly violated by both governments and not legally recognized by either. The final boundaries of Texas would not be determined until the Treaty of Guadalupe Hidalgo was signed in 1848 at the conclusion of the Mexican-American War.

Chapter 7

SAM HOUSTON AND MIRABEAU LAMAR

A Contrast in Visions

Former presidents of the Republic of Texas Sam Houston and Mirabeau Lamar differed in many ways. Some of the differences were personal and unimportant in the political scheme of things. Houston loved flashy clothes and had a reputation for frontier boldness, while Lamar preferred somber dress and enjoyed quieter pastimes such as reading and writing poetry. However, both men were strong leaders, and their vastly different visions for the new republic would do much to shape the future of Texas.

When Sam Houston took office in 1836 as the first elected president of the Republic of Texas, the new nation faced many problems. Foremost among them was Mexico's refusal to recognize the independence of the republic. Technically, the two nations remained at war. In addition, the new president was forced to deal with severe financial problems based on debts that were incurred during the revolution and relations with the native Texans. Finally, the pressing question of annexation to the United States loomed on the horizon.

Houston believed his primary responsibility as president was to prevent another war with Mexico. In accordance with this policy, he appointed Stephen F. Austin as his secretary of state. Austin spoke fluent Spanish, and it was hoped that the friendly relations he established with many Mexican officials as an empresario prior to the revolution would aid in peaceful relations between the two countries. However, Houston's hopes were dashed when Austin took sick and died at the age of forty-three on December 27, 1836, after serving less than three months in office.

Adding to the growing tensions with Mexico were hundreds of newly arrived United States citizens eager for battle, though they had come to Texas too late to fight in the revolution. Instead of calming the situation, the commanding general of the Texas Army, Felix Huston, incited the new arrivals by speaking out in favor of renewing the conflict with Mexico. To prevent further bloodshed, President Houston sent General Albert Sidney Johnston to relieve Huston. However, when Johnston attempted to take command, Felix Huston challenged him to a duel. Honor required that Johnston accept the challenge, and subsequently he was severely wounded. Sam Houston wisely defused the situation by sending all but six hundred soldiers home on leave and refusing to call them back to duty. President Houston's decision to disband the majority of the Texas Army also saved the government a good deal of money, but it did not solve the republic's financial problems.

Texas incurred a debt of more than $1 million fighting the revolution. Houston was forced to cut expenses to the bone while trying to raise revenue for those items he considered essential by levying customs duties and property taxes. In spite of his efforts, the tax collections resulted in little revenue, and the debt continued to rise. In 1837, at Houston's urging, the Texas legislature authorized the issuance of $600,000 in promissory notes to pay government expenses. The promissory notes represented a government promise to pay a specified sum to the holder at a future date in exchange for the cash value of the notes at the time they were issued. Dubbed "Star Money" because of the star prominently displayed on the front of the bill, the notes circulated at or near face value for most of Houston's presidency. However, when financial prospects failed to improve, people began to reject the notes as legal tender.

In addition to tensions with Mexico, the new republic faced growing conflicts with the native Texans, who resented settlers moving onto lands they claimed as their own. Although President Houston was sympathetic toward the Indian population, most Texans failed to share his views. Prior to the revolution, Houston had negotiated a treaty with the Cherokees whereby they were promised title to the land they occupied in East Texas in exchange for remaining neutral during the conflict. However, East Texas was some of the richest farmland in the republic, and many Texans were in favor of removing the Cherokees in spite of the treaty. Though the Cherokees remained relatively peaceful in the face of this threat, other Texan tribes, including the fierce Comanches, fought back. Houston enlisted the aid of the Texas Rangers to keep the peace on the frontier, but the attacks continued.

Of all the problems facing the new republic, Houston was most concerned with the process of annexation by the United States—a move that he felt

would alleviate most of the problems. During his election, a majority of the electorate voted in favor of annexation. After all, many Texans emigrated from the United States, bringing their language, customs and ideas about laws and government with them. The addition of Texas would also allow for westward expansion and help the United States fulfill its "manifest destiny." In light of these factors, the citizens of the Republic of Texas were sure that they would be welcomed into the Union with open arms.

With the assistance of several Texans, including William H. Wharton and Anson Jones, members of the U.S. Congress who favored annexation introduced a bill to admit Texas into the Union. Unfortunately, former United States president John Quincy Adams, now a member of the House of Representatives, led the fight to block the bill's passage. Adams, an avowed abolitionist, was determined not to admit any state that supported slavery, and many other politicians opposed to slavery agreed with him. The issue dragged on until Houston, in an attempt to save Texas from embarrassment by any more foot dragging, reluctantly ordered Anson Jones to withdraw the annexation request.

The Texas Constitution limited the first president of the republic to a term of two years and stated that no president could be elected for two consecutive terms. Therefore, in 1838, Houston was forced to hand over the reins of government. Later Texas presidents would serve for three years. In the subsequent election, Houston's popular vice-president, Mirabeau Lamar, announced his bid for the presidency. Houston, who thought little of his vice-president and his policies, handpicked Peter Grayson to run against Lamar. When Grayson unexpectedly died, Houston chose James Collingsworth to run, but in another stroke of misfortune, Collingsworth also died before the election.

Lamar would have most likely won the election anyway without the untimely deaths of his opponents because he offered a new vision for the future of Texas—one in sharp contrast to the vision of Sam Houston. Houston had worked to maintain peaceful relations with Mexico and Native Americans, spent as little money as possible and promoted the annexation of Texas. Lamar, on the other hand, stood ready to confront Mexico and drive all the Native Americans out of Texas. He was also willing to borrow large sums of money to support his efforts. Most importantly, he wanted Texas to remain independent from the United States and expand its territory all the way to the shores of the Pacific.

President Lamar's aggressive approach to policy making can best be summed up in his inaugural address, in which he stated, "If peace can be obtained only by the sword, let the sword do its work." In 1840, Lamar

Mirabeau Lamar Monument at Stephen F. Austin University in Nacogdoches, Texas. The inscription reads: "The cultivated mind is the guardian genius of democracy." *Wikimedia Commons.*

heightened tensions with Mexico by sending Commodore Edwin Moore and the Texas Navy to assist the Yucatan rebels in their revolt against the Mexican government. Lamar further angered Mexican officials with his interpretation of the Treaties of Velasco signed by Santa Anna in 1836. The secret portion of the treaty, agreed to by Santa Anna in hopes that he would soon be permitted to return to Mexico, set the boundary between Mexico and Texas at the Rio Grande River. Lamar insisted that this provision included the full course of the Rio Grande—as far north as its headwaters in Colorado—which meant that Santa Fe and half of New Mexico belonged to Texas.

In 1841, President Lamar sought authority from the Texas legislature to send troops to New Mexico to enforce his view, but Congress refused. Undaunted, Lamar exercised his own authority and sent General Hugh McLeod with 270 men to Santa Fe under the guise of a trading expedition with orders to convince the New Mexicans that they should join the republic. However, after straggling across the dreaded and uncharted Llano Estacado, the men arrived in Santa Fe dying of thirst and nearly starved. With no

other choice, the Texans surrendered and were immediately put in chains and marched 1,500 miles to Mexico City, where they were imprisoned until 1842. The disastrous expedition resulted in the needless loss of life and the expenditure of money Texas did not have.

When the financial situation in the republic continued to degrade, Lamar decided to print more money, a decision that would prove to be ill-fated. The money, known as "redbacks" because of the color of the ink used on the reverse side of the bills, was backed by nothing but empty promises and fell steadily in value until a Texas dollar was worth only about twelve U.S. cents. Nevertheless, Lamar continued to seek additional credit, and the public debt increased to almost $7 million by the end of his term in office.

Unlike that of Sam Houston, Lamar's policy toward Native Americans called for the Indians to be either removed from Texas or exterminated. He began by ordering Chief Bowles to lead his Cherokee people out of East Texas. When Bowles refused, Lamar sent General Kelsey Douglas and the Texas militia to drive the Indians out. Lamar had similar plans for the Comanches, but the "Lords of the Plains" proved to be a much more superior foe. After a few skirmishes with the Texas Rangers in 1839, Comanche leaders sought peace. Talks were held at the Council House in San Antonio on March 19, 1840, but fighting broke out, and many Comanche leaders were killed in what became known as the Council House Fight. The Comanches retaliated with the Great Raid of 1840 and the burning of Linnville.

President Lamar was best known for his farsighted education policy. A public education system had always been at the forefront of Texas thought. The Texas Declaration of Independence listed the Mexican government's failure to establish public schools as one of its major grievances. In 1838, Lamar spoke of the importance of public education, characterizing it as a universal necessity when he said, "It is admitted by all that the cultivated mind is the guardian genius of democracy and…is the noblest attribute of man." The Texas legislature responded to Lamar's words of wisdom by setting aside 18,000 acres in each county for public schools and 220,000 acres for two universities. Lamar became known as the "Father of Education."

In the election of 1841, Sam Houston was once again eligible to run for president. Though Texas did not have political parties, a clear division in the electorate stood between those individuals who supported Houston's policies and those who supported Lamar's. Houston easily carried the election, defeating Lamar's vice-president and choice of candidate David G. Burnet on a platform of preventing war with Mexico, cutting government expenditures and seeking annexation to the United States.

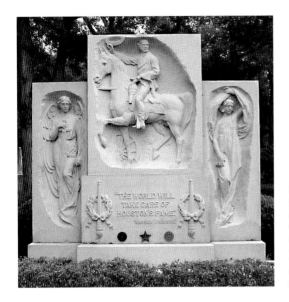

Sam Houston Monument by famed sculptor Pompeo Copini, Oakwood Cemetery, Huntsville, Texas. The inscription reads: "The world will take care of Houston's fame." *Courtesy of Barclay Gibson,* Texas Escapes *magazine, October 2010.*

President Houston wasted no time in implementing his policies. First, he concentrated on government spending by cutting salaries (including his own), reducing the size of the army and tackling the problem of the Texas Navy, which was conducting what amounted to Lamar's private war in support of Yucatan's rebellion against Mexico. He ordered Commodore Moore to return to Texas from Yucatan, and when Moore defied Houston's orders and sailed to New Orleans to repair his ships and supply his crews, the president declared the commodore a pirate and invited other nations to sink his ships. Moore quickly returned home. Houston disbanded the navy and sold the ships, adding the money to the treasury. As a result of these actions, Houston spent less than $600,000 during his three-year term.

Finally, Houston turned his attention to the critical question of annexation. John Tyler of Virginia had assumed the presidency of the United States after the death of William Henry Harrison, and in April 1844, his secretary of state, John C. Calhoun, agreed to a treaty that would have admitted Texas as a territory. The treaty failed in the U.S. Senate, but in the 1844 U.S. presidential election, the Democratic Party, which called for the annexation of Texas, nominated James K. Polk of Tennessee. Polk won the election, and the U.S. Congress approved a joint resolution on February 26, 1845, accepting Texas as the twenty-eighth state in the Union. Houston's long dream of annexation had become a reality.

Although the visions of Sam Houston and Mirabeau Lamar stand in sharp contrast, both men made vital contributions to the fledgling Republic of Texas. Lamar's aggressive policies helped steer the republic through troubled times and have come to represent the bold image for which Texans are known throughout the world, while Houston's level-headed brand of leadership added credibility to the new nation, and his persistence in seeking annexation secured the future for all Texans.

Chapter 8

THE QUESTION OF A CAPITAL

The Revolving Carousel of the Republic's Seat of Government

Though the Republic of Texas lasted for only a few brief years, its capital shifted locations several times—from the capital of Stephen F. Austin's original colony, San Felipe de Austin, to the present-day capital of Austin, a town created for the sole purpose of serving as the new nation's capital. In between, Washington-on-the-Brazos, Harrisburg, Galveston Island, Velasco, Columbia and Houston all held the seat of power, if only for a brief moment.

San Felipe de Austin was founded in 1824 near the site of John McFarland's ferry, where the Atascosito Road, which connected San Antonio to Louisiana, crossed the Brazos River. San Felipe became the second-largest town in colonial Texas, with a population of around six hundred in 1835. Stores that carried merchandise imported from the United States and inns and taverns that provided lodging and meals offered travelers the only respite in a wilderness that spanned the nearly four hundred miles from Nacogdoches to San Antonio. One of Texas's first newspapers, the *Texas Gazette*, began publication in San Felipe in 1829, and its printing press put out the first book ever published in Texas.

San Felipe de Austin was also the center of political activity in Texas before independence was declared. The "People of Texas" met in session there three times to protest Mexican policies and to eventually consider breaking free of Mexico, first at the Conventions of 1832 and 1833 and finally at the Consultation of 1835. San Felipe also played a key military role in the revolution. After the disaster at the Alamo, Santa Anna ordered his armies to converge on San Felipe. The Texas Army, commanded by Sam Houston,

retreated from Gonzales to San Felipe and then retreated farther east as the Texas settlers fled in what became known as the "Runaway Scrape." On March 29, 1836, Houston ordered San Felipe put to the torch to deny Santa Anna's army a source of supply. The McFarland ferry was also destroyed. Unable to cross the Brazos River, Santa Anna was forced to turn southward.

Many of San Felipe's colonial residents failed to return after the revolution, and the town never regained the prominence it had held prior to its destruction. With the formation of Austin County and San Felipe's designation as the county seat, the town at least remained a center of local government for a time. However, the Texas government did not return, and within a decade, the county seat was moved to Bellville. San Felipe remained a small rural community well into the twentieth century, taking more than 150 years to regain the population it had once held prior to the revolution.

With the Convention of 1836 on March 1, the capital shifted to Washington-on-the-Brazos. The convention, which claimed and exercised all powers of sovereignty, adopted a declaration of independence on March 2. The delegates also wrote a constitution and selected an ad interim government headed by David G. Burnett as president. The delegates adjourned on March 17 when a report reached town that Mexican cavalry had occupied Bastrop, only sixty miles away. The news created a state of panic. In the words of one distraught delegate, the Texans were "hourly exposed to attack and capture, and perhaps death." Three days after it was established, the provisional government packed everything up and fled seventy miles eastward to the new capital of Harrisburg on Buffalo Bayou.

With the Mexicans in hot pursuit, the capital of the Republic was anywhere that President Burnet happened to hang his hat for the following few weeks. On April 14, Santa Anna reached Harrisburg only to find that Burnet and his government had escaped the previous morning on the steamer *Cayuga*. The steamer headed down Buffalo Bayou to the San Jacinto River and the town of New Washington on Galveston Bay. The water route to New Washington followed many twists and turns, but the town was only twenty miles away by road, so Santa Anna immediately dispatched a troop of dragoons in the hope of capturing Burnett. The dragoons arrived in time to see the president escaping by rowboat to a schooner that would take him and the government to Galveston, the next stop on the capital carousel.

From Galveston, President Burnett moved the capital to Velasco, where he negotiated with General Santa Anna after he was captured by Sam Houston at the Battle of San Jacinto. The capital remained in Velasco until President Burnett declared Columbia the capital city—the small town in Brazoria

County where the Texas legislature met for the first time on October 3, 1836. However, many Texans complained that Columbia was too small and isolated to serve as the capital. They wanted to find a new location. John and Augustus Allen provided an answer to their dilemma.

The Allen brothers arrived in Texas from New York in 1832. John was a bright, fresh young senator, while Augustus, his dour brother, was a bookkeeper who provided the partnership with financial expertise. In 1836, the brothers acquired a tract of land on Buffalo Bayou, not far from the former town of Harrisburg, which had been burned in the revolution. They named the site in honor of Sam Houston in hopes of gaining his support in the search for a new capital. The Allen brothers promoted their town by declaring that Houston was "located to command the trade of the largest and richest portion of Texas." As an incentive, John Allen offered to build a capital building at his own expense to house the government. The offer was too good for congress to turn down, and Houston was named the capital.

When the government moved to Houston in April 1837, the capital building was still unfinished, but congress convened without further delay. Lured by the promise of government business, merchants and craftsmen flocked to the new capital. Log cabins and shacks of all varieties began to appear willy-nilly on unplanned streets, but there were not nearly enough of them to accommodate the flood of settlers. The *Houston Telegraph* reported, "This city is increasing with rapidity unequaled by that of any city in Texas." Unfortunately, many of the newcomers were far from desirable citizens. Mary Holly, Stephen F. Austin's cousin, jokingly wrote that the attraction of the riffraff to Houston might well have been a blessing. As she saw it, the city "concentrates the rascals, with the government and its hangers-on, & leaves the rest of the people in peace."

Unfortunately, with so many people crowded together in an area without adequate sanitary facilities, the spread of disease was inevitable. People initially fell sick from drinking foul water straight from the bayou, but that problem was solved when congress invested $500 in the construction of several cypress cisterns to collect fresh rainwater. John Allen died in 1838 of what was most likely yellow fever, and 240 citizens perished in an epidemic the following year. In spite of the problems, there were also encouraging signs of stability. The first school opened in 1839, quickly followed by the first theater, a jail and a courthouse. Organizations like the chamber of commerce and a local chapter of the Masonic Lodge also sprang up. However, just as things began to improve, congress started to speak of moving the capital once more.

The speculation was not without cause. Houston's low, marshy location on Buffalo Bayou, the nearly unbearable summer humidity, the presence of yellow fever and other disease and the inadequate makeshift accommodations were all ample reasons for complaint. Though many alternate sites were discussed, one location in particular—the present location of the tiny village of Waterloo—impressed newly elected Mirabeau Lamar. Lamar first saw the site for the proposed capital located on a bend in the Colorado River while on a buffalo hunt during his term as vice-president. He admired the location not only for its scenic beauty but also for its dry, healthy climate. Lamar recommended the site to a five-man commission appointed for the purpose of selecting a new capital, and after a careful appraisal, the commission approved the president's recommendation.

Opponents of the commission's choice complained that the site for the new capital lay too far north in the "middle of nowhere." They also protested that the location bordered on the Comancheria and would require constant defense from the dreaded Comanches. The protests were joined by the citizens of Houston, who were worried that their city would wither on the vine if it lost the prestige of being the capital. However, in spite of the protests, congress voted to approve the new location and rename it Austin in honor of the "Father of his Country," Stephen F. Austin. Demonstrating that it had learned a lesson from the mistakes made at Houston, the government appointed Edwin Waller to take charge of the new capital's development.

Waller, a signatory of the Declaration of Independence, was born in Spotsylvania County, Virginia, on November 4, 1800. He represented Columbia at the Consultation of 1835 and served as a delegate from Brazoria to the Convention of 1836. As a member of the convention, he served on the committee that framed the republic's constitution. Determined to develop a town the republic would be proud to call its capital, Waller proceeded with honesty, foresight and meticulous care. Under his supervision, a team of surveyors carefully laid out a town divided by a broad central boulevard named Congress Avenue. The design would allow Austin to expand gracefully, unlike the helter-skelter sprawl that hampered most frontier towns. Waller also sold 306 building lots at auction for the benefit of the Republic of Texas instead of greedy speculators.

Construction on the capital began in May 1839. First, Waller built an eight-foot-high stockade to surround the new capitol building. Comanches were known to roam the streets at night, and every now and then a careless citizen would lose his hair. A local politician reported, "You were pretty sure to find a congressman in his boarding house after sundown." The capital

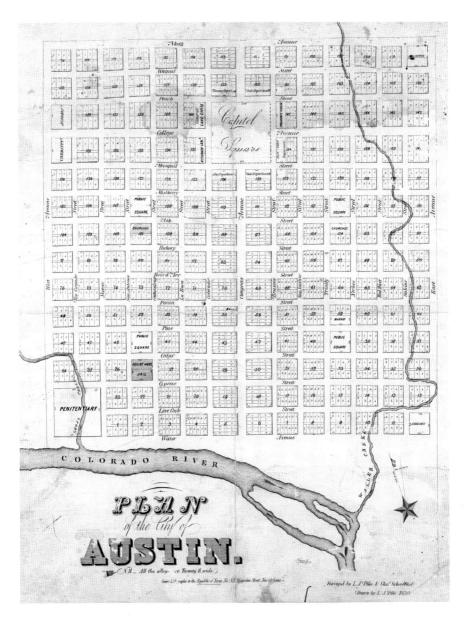

"Plan of the City of Austin," 1839. Engraved by Fishbourne. *Courtesy of Texas State Library and Archives Commission.*

was officially incorporated by the end of 1839 under the name Waterloo, but shortly thereafter, the name was officially changed to Austin. By 1840, Austin began to spread outward from Congress Avenue, and its 856 residents elected Edwin Waller mayor for the valuable service he had rendered to the new capital.

Unfortunately, the city of Austin had a very influential enemy. Sam Houston often described the new capital as "the most unfortunate site on earth for a seat of government," and when he was elected to the presidency again in 1841, he refused to move into the official residence, preferring instead to take a room at a boardinghouse run by Mrs. Angelina Eberly. Then, in February 1842, Houston saw his chance to return the capital to his namesake. A Mexican force of one thousand troops under the command of General Raphael Vasquez invaded Texas and occupied San Antonio. Fear quickly spread that the troops would move on the capital, and the president, arguing that the city was defenseless against attack, ordered a special session of congress to meet in Houston. He also ordered the secretary of state to move the government archives to Houston.

Knowing that as long as the government archives remained Austin would be recognized as the official capital, the citizens banded together and formed a vigilante "Committee of Safety," warning the government officials who remained in the capital that any attempt to remove the official papers would be met with armed resistance. When his attempt to revive the city of Houston as the capital failed, Sam Houston compromised by ordering congress to meet at Washington-on-the-Brazos, where the Declaration of Independence was signed in 1836. After the government was established, Houston sent Captain William Pettus to collect the archives, but when the captain rode into Austin, the vigilantes lopped the mane and tail off his horse and sent him back to Washington-on-the-Brazos empty-handed.

Frustrated, President Houston dispatched Captain Thomas Smith to make off with the archives under the cover of darkness. Late in the evening of December 30, 1842, Mrs. Eberly, whose boardinghouse business would suffer if the capital were moved, spotted Captain Smith loading the archives into a wagon. She ran to the top of the hill on Congress Avenue and touched off the cannon that stood in front of the stockade surrounding the capitol building. The blast aroused the town. An armed posse of vigilantes ran Smith down at Brushy Creek and retrieved the records. The vigilantes threatened that anyone else trying to steal the records would be shot.

With Captain Smith's failure, the "Archives War" was over, and Sam Houston made no further attempts to move the records. For the next several

years, Austin had more than its share of troubles, and the population declined to a modest 629. However, in spite of the problems, a general election held in 1850 voted Austin to be the permanent site of the capital, and by the end of the boom that occurred during the 1850s, the population had risen to a robust 3,494. At last the capital had found a permanent home.

Chapter 9

CHIEF BOWLES AND THE BATTLE
OF THE NECHES

The Destruction of the Eastern Texas Tribes

As far back as 1807, a small band of Cherokee Indians established a
village along the Red River. That same year, the Cherokee, Delaware,
Kickapoo, Caddo and a few other tribes petitioned Spanish officials in
Nacogdoches and were granted permission to settle in northeastern Texas.
Cherokee immigration increased steadily between 1812 and 1819, when
Chief Bowles (also known as Chief Duwali) and his people established
settlements on the Neches and Angelina Rivers. Bowles, who became
the principal Cherokee chief in Texas, was born of a Scottish father and
Cherokee mother in North Carolina around 1756. In early 1810, Chief
Bowles and his band moved west of the Mississippi River to access better
hunting grounds and escape the growing pressure of settlement in the
southern United States. Their steady westward movement continued until
they reached Texas.

In 1822, Chief Bowles sent diplomatic chief Richard Fields to Mexico
City to negotiate with the Spanish for a land grant in northeast Texas.
Though their request was denied, the Cherokees continued to live in peace
and in 1827 helped the Mexican government put down the Fredonian
Rebellion—an attempt by empresario Haden Edwards to establish an
independent republic in North Texas. In 1833, Chief Bowles again appealed
to Mexico for a land grant, but the negotiations were interrupted by unrest
in Texas. In 1836, Sam Houston negotiated a treaty with the Cherokees
whereby they agreed to remain neutral in the Texas Revolution in exchange
for title to the lands they occupied in northeast Texas. The Cherokees

kept their word and remained neutral, but unfortunately, the Texas Senate invalidated the treaty shortly after the revolution.

During the years following the Texas revolution, it was Mexican policy to stir up Indian trouble on the Texas frontier. The Treaties of Velasco were repudiated by the Republic of Texas and Mexico, and although fighting no longer raged, the countries were still technically at war. Mexico centered much of its efforts in northeast Texas among the Cherokees. Of course, the promise was full title to their lands if Texas once again became a province of Mexico. Apparently, the ultimate goal of the Mexican government was to establish an Indian nation as a buffer between the United States and Mexico.

On May 18, 1839, evidence of an Indian and Mexican plot was uncovered by the Texas Rangers. A company of seventeen rangers under the command of Lieutenant James O. Rice surprised a party of Indians on the San Gabriel River about twenty-five miles north of Austin. The surprise attack was successful, and the Rangers captured six hundred pounds of gunpowder and more than one hundred horses. More importantly, one of the men killed in the attack was a Mexican agent, Manuel Flores. In Flores's possession the rangers discovered papers that told of a Mexican plot to unite all the Texas Indians in one great attack that would be supported by an invasion across the Rio Grande. The detailed plans were penned in the Mexican border town of Matamoros and included tactical advice. The Indians were to stir up trouble and then wait for the Texas militia to ride out before attacking the settlements. Another letter in Flores's papers was from a Mexican agent named Vincente Cordova, who preached rebellion among the Hispanic residents of Nacogdoches. Cordova wrote of a promise by the Cherokees to join the fight against the Anglos.

Certainly the Cherokees had held talks with the Mexicans, but all of the evidence pointed to the fact that Chief Bowles had no intention of joining a war against the Texans. The Cherokees had lived in Texas for nearly twenty years and, except for a few minor incidents, had always been at peace with the whites. Their society was agrarian, and it was rapidly moving toward civilization. They also remained in close contact with Sam Houston. The only crime the Cherokees committed was possessing land that was both rich and bountiful and coveted by the Texans. However, with news of the Mexican plot, the idea of any Indians within the boundaries of the republic became intolerable to the vast majority of whites.

In their plans, the Mexicans had made it clear that the Indians would be free to slaughter the whites at will and take possession of their property, and as word of the Flores papers spread across Texas, a wave of fear and indignation

swept the republic. President Lamar's Native American policy had always been one of either expulsion or extermination, and now the discovery of the Flores papers made it possible for him to carry out that policy by declaring war on the peaceful Cherokees. Secretary of War General Albert Sidney Johnston assembled a force of approximately nine hundred men made up of several units of the Texas Army and reinforced by the Texas militia. The combined force was placed under the command of militia general Kelsey H. Douglas.

On July 12, 1839, Lamar dispatched a peace commission to Chief Bowles, composed of Vice-President David Burnet, General Johnston, James S. Mayfield, I.W. Barton and Thomas J. Rusk, to demand the Cherokees' voluntary removal from the republic. Lamar also made it known that the Cherokees would be forcibly removed if the commissioners failed to bring about a peaceful settlement. The Indians would be paid for any improvements left on the land, but not the land itself. During the negotiations, Chief Bowles conducted himself with grave dignity, politely disagreeing with the commission's terms. The Cherokees owned this land, he said, or should own it, by right of longtime possession and improvement. Bowles went on to say that although he was sure his people could never defeat the more powerful whites, he knew and understood their temper. They would fight, although he advised against it. He then requested that the Cherokees be permitted to gather their harvest before the commencement of hostilities. The Texans refused.

On July 15, Chief Bowles ordered the main Cherokee town evacuated, but the Indians were attacked in the late afternoon as they retreated north. The Texans advanced up Battle Creek with Colonel Landrum's regiment crossing the Neches to block any attempt at reinforcement and to cut off the Indians who tried to continue their northern retreat. Taking cover on some high ground, the Cherokees opened fire on the advancing Texans but were driven back under intense return fire and retreated into a wooded ravine. Landrum was misled by his scouts and failed to block their withdrawal. In the ravine, the Cherokees were well entrenched behind a high creek bank with thick woods to their rear to provide either a safe retreat or a good secondary line of defense. Meanwhile, the Texans were faced with a stretch of open prairie between them and their adversaries.

General Douglas ordered Colonel Rusk to advance his regiment across the open field. They were joined by the men under Colonel Burleson. Douglas later wrote, "As we advanced, the lines were immediately formed and the action became general." A company under the command of Captain Sadler took a position on a hill to the right and drove into the ravine from that quarter, flanking the Cherokee position. The firing from the ravine was

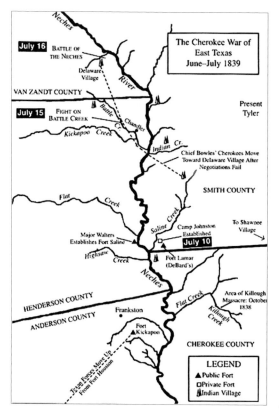

Left: Map of the Battle of the Neches. *Wikimedia Commons.*

Below: Battle of the Neches battlefield near the site of the Delaware village, Van Zandt County, Texas. *Photo courtesy of Jeffery Robenalt, March 2010.*

intense as the Texans advanced, and both sides suffered casualties from the heavy fighting that continued into the fading twilight. Many Texans finally dismounted and charged into the ravine on foot, driving the Cherokees from the protection of the creek bank. The Indians soon fled, carrying off many of their wounded. Eighteen dead Cherokees were found on the battlefield, while the Texan losses consisted of two killed and six wounded.

The Cherokees retreated several miles during the night before they were located the following day by the Texas scouts near the headwaters of the Neches River in present-day Van Zandt County. Two Texas regiments under the command of Colonels Rusk and Burleson broke camp at 10:00 a.m. and renewed their pursuit. In his official report, General Douglas wrote, "The effective force of the two regiments this morning amounted to about 500." Douglas's forces moved toward the Delaware village of Chief Harris, with Burleson's regiment on the right and Rusk's to the left. The village was located on a wooded hill just west of present-day Tyler. Below the hill, heavily timbered bottomland stretched away toward the Neches River.

At about 11:00 a.m., as the Texans were nearing the village, the scout company commanded by Captain Carter came under fire from a small group of Indians concealed in the trees. General Douglas ordered Burleson to advance in support of Carter, and the Indians quickly fell back. The Texans pursued them through the deserted village only to encounter the main body of Chief Bowles forces, which had taken up a defensive position in a ravine on the lower side of the hill. As the Texans scrambled to dismount, concentrated fire from the ravine killed one man and several of the horses. Douglas then ordered Rusk's regiment to advance in support of Carter and Burleson. They set fire to the village as they rode through, and thick clouds of black smoke billowed high into the noonday sky.

Rusk quickly put his men on line when they cleared the village and ordered them to dismount. Every sixth man was left behind to tend the horses while the others advanced down the hill from the burning village and took up positions in the trees on the lower slope to bring fire on the Indian forces barricaded in the ravine. Ignoring their thirst in the sweltering heat, Rusk's Texans made several charges on the ravine, but the Cherokees were determined to stand firm, and their heavy counter-fire forced each attempt to withdraw back up the slope into the cover of the trees. Frustrated by the lack of success, General Douglas ordered Burleson's regiment down the slope and put them on line with Rusk's men. The combined charge finally overran the ravine, and the Indians fell back in disorder toward the ripe cornfields and open prairie along the river.

According to one of the Texans, "Chief Bowles displayed great courage in the battle," remaining on horseback during the entire engagement. Bowles wore a military hat, silk vest and a sword that was a gift from Sam Houston. "He was a magnificent picture of barbaric manhood and was very conspicuous during the whole battle, being the last to leave the field when the Indians retreated," the Texan continued. Chief Bowles tried valiantly to rally his forces after the Texan charge scattered the Indians across the cornfields and open plain. Remaining on horseback, he exposed himself to danger time and again. Bowles's horse was hit seven times before the Indians withdrew, and he was eventually shot in the hip. Suffering from his wound, Bowles dismounted his dying horse and began to limp away when he was shot in the back.

Sergeant Charles Bell of the Nacogdoches Company later wrote that he and Captain Bob Smith found Bowles "sitting in the edge of a little prairie on the Neches River." The resolute chief was still armed with a knife and his pistols, but according to Bell, he "asked no quarter. Under the circumstances, the captain was compelled to shoot him." Bell then witnessed Smith put his pistol to Bowles's head and kill him before taking his sword. The Texans took strips of skin from Chief Bowles's arms as

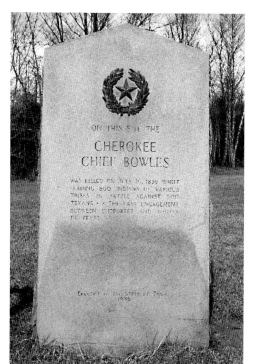

souvenirs, and his body was left where it lay, without burial. In addition to the chief, about one hundred other Indians lay dead on the Neches battlefield. The Texans had two dead and thirty wounded, including Vice-President Burnet and General Johnston.

Chief Bowles historical marker, Van Zandt, County, Texas. The inscription reads: "On this site, the Cherokee Chief Bowles was killed while leading 800 Indians of various tribes in battle against 500 Texans…the last engagement between Cherokees and whites in Texas." *Photo courtesy of Jeffery Robenalt, March 2010.*

After the death of Chief Bowles, the remaining Cherokees retreated across the Neches, but the survivors returned at dusk to recover the wounded and the bodies of the dead. All through the long night the Texans listened to the Cherokee wails of mourning for their dead, but by sunrise, the mournful sounds had ceased and the Indian camp was deserted. The Cherokees had begun their sorrowful flight to Oklahoma Indian Territory. However, General Douglas was not content to simply rid the republic of the Cherokees. He recommended to President Lamar that the entire Indian "rat's nest" be burned out and that all the villages and crops of the East Texas tribes be destroyed. By July 25, the Delaware, Kickapoo, Caddo, Shawnee, Creek, Muscogee, Biloxi and Seminole tribes were also driven out of the republic. Only the small and weak Alabama and Coushatta tribes were permitted to remain, and they were removed to a small reservation on less fertile land.

Sam Houston and a few other advocates for the eastern Indian tribes were sickened by the slaughter and openly critical of President Lamar for his harsh policies. However, the battle did put an end to the Indian depredations that had terrorized the early settlers and provided the republic with a rich new source of land. In the brief but glorious history of the Republic of Texas, the Battle of the Neches has been described as second in importance only to the Battle of San Jacinto as the most decisive conflict fought on Texas soil.

Chapter 10

THE SAN ANTONIO COUNCIL
HOUSE FIGHT

A Comanche Effort to Reach Peaceful Relations

Mirabeau Lamar was elected president of the Republic of Texas, in part by insisting that the only permanent solution to the Indian problem was to expel the tribes from Texas and to exterminate all Indians who refused to leave the country peacefully. Soon after assuming office, he moved to implement this policy when he ordered Chief Bowles to lead his people out of Texas. Bowles refused, and on July 16, 1839, the militia, bolstered by a few soldiers from the Texas Army, attacked the main Cherokee village located on the Neches River. Chief Bowles was among those killed during the fighting, and the Cherokees were forced to hurriedly pack up a meager portion of their possessions and move to present-day Oklahoma. The remaining eastern tribes soon met an identical fate.

President Lamar intended to oust the Comanches in the same aggressive and violent manner, but the fierce "Lords of the Plains" were a far cry from the numerically weak and nearly civilized Cherokees. Over the years, the Penateka band of Comanches, or "Honey Eaters," had waged a continuous and bloody hit-and-run war with the settlers along the frontier north and west of Austin. The Penateka were one of five major Comanche bands. They ranged from the Edwards Plateau to the headwaters of the Colorado and Brazos Rivers. North of Penateka country, the Nokonis, or "Those Who Turn Back," roamed from the Cross Timbers region of Texas to the mountains of New Mexico. Still farther north along the Canadian River ranged the Kotsotekas, or "Buffalo Eaters." The northernmost band of Comanches was known as the Yamparikas, or "Yap Eaters," a name derived

from an edible root. Their territory extended north to the Arkansas River. The fifth major band of Comanches, the Quahadis, or "Antelope People," lived out on the high plains of the Llano Estacado.

Lamar began his move against the Comanches when he ordered his newly formed Texas Ranger companies to carry the fight into the fringes of the Comancheria. The rangers were told to attack any hunting parties they happened to come across and any villages that happened to be located by their far-ranging Tonkawa scouts. Although these attacks on the basic way of Comanche life were not always successful, they eventually convinced the Penateka that the cost of continued fighting would carry a high price. As a result, on January 9, 1840, three Penateka peace chiefs rode into the old mission town of San Antonio seeking a parley with the commandant of the military post, Colonel Henry Karnes.

The Comanche way of life was dictated by a democratic principle that was deeply ingrained in their political organization. Each tribal division or band was led by both peace chiefs and war chiefs, but tradition held that the head peace chief was the most influential. However, neither peace chiefs nor war chiefs were elected. Instead, they were chosen by the common consent of the people. A leader gained his position by displaying special abilities or prowess and retained his authority only so long as he maintained the confidence of the other band members. All important decisions were made for the band by a council of chiefs presided over by the head peace chief, but none of the individual members of the band were obligated to follow the decisions of the council. Comanche society was a pure democracy that honored each individual's freedom to choose—a concept never truly understood by the Texans and one that would greatly complicate the peace negotiations.

At the meeting, the peace chiefs assured Karnes that the Comanches had refused to treat with the Mexican centralists who were attempting to stir up trouble on the frontier and that all five Comanche bands were ready to sit down with the whites to negotiate a peace treaty. Karnes refused to consent to the negotiations "without the release of the American Captives, and the restoration of all stolen property; besides giving guarantees that future depredators on our property should be delivered up for punishment." At the time, it was believed that the Comanche captives numbered around two hundred. The chiefs agreed and promised to return to San Antonio in twenty days.

Fearing that the Comanches would fail to keep their promise, Colonel Karnes wrote to Secretary of War General Albert Sidney Johnston requesting his assistance. Johnston, too, trusted little in Comanche

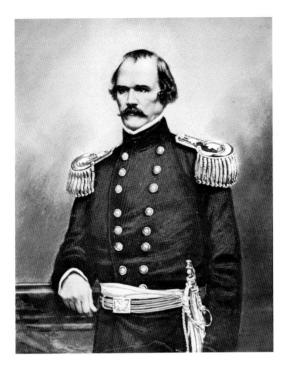

Secretary of War General
Albert Sidney Johnston.
Wikimedia Commons.

promises, and he ordered Colonel William S. Fisher, commander of the
First Regiment, to march to San Antonio with three companies of infantry.
Fisher was also told not to present gifts to the Comanche negotiators as
was the usual custom and was ordered to capture the Indians who came to
the meeting and hold them hostage if the white captives were not returned
as promised. General Johnston appointed Fisher, Adjutant General Hugh
McCleod and Colonel William G. Cooke as peace commissioners to carry
out the negotiations.

On March 19, 1840, sixty-five Comanches—including men, women and
children—boldly paraded into the streets of San Antonio. The brightly
painted and attired contingent was led by twelve peace chiefs, including
the renowned Muguara, or "Spirit Talker." Unfortunately, the Comanches
arrived for the meeting with only two captives: a sixteen-year-old girl,
Matilda Lockhart, and a young Mexican boy the Texans refused to consider.
To make matters worse, the young girl's condition was abhorrent. Her face
and body were covered with bruises and sores, and the end of her nose was
burnt off down to the bone. Comanche squaws routinely woke her from
sleep by sticking a hot coal against her flesh, usually to the tip of her nose.
Matilda had lived with the Indians for nearly two years and understood some

of their language. She told the Texans that the Comanches held thirteen more captives in their camp but hoped to get a higher price by returning them one at a time.

The meeting took place in a small one-story limestone building on the corner of Main Plaza and Calabozo Streets known as the Council House. The flat-roofed, earthen-floor structure adjoined the old stone jailhouse near where city hall now stands. When Chief Muguara and the other peace chiefs entered the Council House, the Comanches not involved in the negotiations remained outside in the courthouse yard, where a few young boys entertained the townspeople with demonstrations of their skill at shooting arrows. Meanwhile, without the usual pleasantries, Muguara demanded higher prices for the remaining captives. Ignoring the peace chief's outrageous demand, the commissioners immediately insisted on knowing why the other prisoners had not been returned as promised. Muguara answered that they were held by other Comanche bands but could all be purchased for the right price. The chief then asked, "How do you like answer?"

After seeing the mutilation of the young Lockhart girl, the commissioners were furious, and Colonel Fisher ordered some of the soldiers who surrounded the outside of the Council House to enter the meeting room. Fisher then ordered a reluctant interpreter to tell Muguara that he and the peace chiefs would be held as hostages until the remaining white captives were retuned. After delivering the threat, the frightened interpreter turned and fled from the room. The March 24, 1840 *Texas Sentinel* provided a detailed account of "a recent battle with the Comanches at San Antonio":

> *Pandemonium ensued as the Comanches responded with shrill war cries and rushed for the door. A war chief stabbed a soldier who attempted to block the door with his body, and Fisher gave the command to open fire. Muguara was killed instantly, and in the confusion caused by echoing blasts of gunfire, howls and screams of the Comanches and thick clouds of swirling black powder smoke, the surviving Comanches broke out of the building.*

The young Comanche boys who had been playing outside during the meeting heard the shouts and gunshots coming from the Council House and joined the fight, firing arrows at any target they could find. Indians, soldiers and spectators alike were killed in the general mêlée that followed. The Comanches fled in all directions down the streets and between the houses. The fighting was short and furious, and in the end, only one renegade Mexican escaped the deadly trap set by Colonel Fisher. Muguara and

the peace chiefs were killed, along with many of the Comanche warriors, women and children. Twenty-seven women and children and two old men were taken prisoner and locked up in the jail. The Texans suffered seven killed and eight wounded.

After the smoke settled, Colonel Fisher ordered that a squaw be given a horse and sent to the Comanche camp with a warning: unless the white captives were returned within twelve days, all the Comanche prisoners held in the San Antonio jail would be killed. The squaw never returned to San Antonio, but eventually a young white boy who was adopted into the tribe told the terrible tale of what happened when she reached the camp. The loss of so many warriors and leaders was a serious blow for any Comanche band to suffer, and the Penateka village went into a frenzy of mourning. Women screamed and howled as they slashed at their arms and legs with razor-sharp flint knives, and men sacrificed many valuable horses to honor the brave dead. However, all this was nothing compared with the ghastly fate suffered by the thirteen white captives. Every one of them was either roasted alive or tortured to death in hideous and lingering ways that only a fierce and vengeful people like the Comanches could devise.

The prisoners captured during the fight at the Council House were later moved from the jail to the Mission San Jose and from there to Camp Cooke at the head of the San Antonio River. They were never guarded closely, and eventually all of them escaped and returned to their own people. While never mistreated, the prisoners continued to be leery of any kindness that was offered. The Comanches briefly remained in the area, stealing horses, burning houses and occasionally attacking individual settlers, but the loss of their chiefs was a serious blow, and they finally began to drift away.

President Lamar's Indian policy and the ill-fated results of the Council House Fight ensured there would be no lasting peace between the Republic of Texas and the Comanche Nation. For a few months after the incident, people in and around San Antonio lived in a state of terror, dreading the revenge they believed would be forthcoming. However, when nothing of note occurred by mid-summer, the Texans assumed that the Comanche threat was gone. This assumption could not have been further from the truth. The Comanches simply melted away deep into the far northern reaches of the Comancheria, where they held a council of war attended by nearly all the bands. Under a brilliant August moon, the "Lords of the Plains" would return in a force heretofore unknown, and Texas would eventually pay a terrible price in blood and suffering during the Great Comanche Raid of 1840.

Chapter 11

THE GREAT COMANCHE RAID AND THE BATTLE OF PLUM CREEK

A Plan of Comanche Revenge

In August 1840, under the silvery light of a brilliant full moon (long familiar to Texas settlers as a "Comanche moon"), a band of several hundred Comanche and Kiowa warriors thundered out of the Comancheria and headed directly for the heart of the Republic of Texas. The huge war party was led by the fierce Penateka war chief Buffalo Hump, or "Po-cha-na-quar-hip." Like most of the other warriors, Buffalo Hump wore only a breach clout and moccasins, his muscular body and horse painted for war. Eagle feathers fluttered in his long, coal-black hair, and brass rings encircled his arms. A single string of beads hung loose around his thick neck.

The massive raid was launched in retaliation for what the Comanches perceived to be the unprovoked killing of twelve peace chiefs and many innocent women and children at the Council House talks in San Antonio just a few months before. Initially concealing their presence by riding through an area of sparse settlement to the east of San Antonio, the warriors spread out and cut a wide swath of destruction across the fertile lands between the Guadalupe and San Antonio Rivers. The settlers who were lucky enough to receive a warning fled before their homes were burned and their livestock slaughtered or scattered, but many died where the Comanches found them. The ones who died quickly were the fortunate few.

Killing and burning along the way and slaughtering an unlucky victim here and there, the warriors did not halt their movement southeast until they reached the old settlement of Victoria late in the afternoon of August 6. Sweeping undetected down the valley of Spring Creek, the Comanches

quickly surrounded the town. Buffalo Hump then did something that no war party had ever attempted before when he led his warriors in an attack to overrun the town. With no knowledge of hostiles in the area, the citizens thought the approaching Comanches were a group of Lipan Apaches, friendly Indians who occasionally came to Victoria to trade. It was not until the warriors began to scream their war cries as they advanced that the people realized what was happening. The element of surprise prevented a concentrated defense, but many citizens saved themselves by quickly banding together and forting up in scattered residences and businesses on the outskirts of town. Though two people were killed and several more wounded, their heroic efforts prevented the Comanches from breaking into the center of town.

The Indians rounded up all the horses they could find, including 500 head belonging to Mexican traders that were staked out on the prairie not far from town alongside a large number that had recently been brought to Victoria by "Scotch" Sutherland. Late in the afternoon, Buffalo Hump withdrew his warriors to Spring Creek, where they killed a settler and two of his slaves and captured a black girl. Instead of gathering their plunder and heading for the Comancheria in the morning as was their usual custom, Buffalo Hump led the warriors in another attack on Victoria, burning one house and looting a few more near the edge of town. Before the smoke from the burning house cleared, the Comanches were again on the move to the southeast, driving a herd of nearly 1,500 stolen horses and mules ahead of them. Continuing down the Guadalupe River bottomlands, the savage hoard burned and killed as the opportunity arose. Though militia companies and other volunteers turned out, their only contribution consisted of burying the dead. All along the Guadalupe houses burned and unwary settlers died.

On the morning of August 8, the Comanches appeared two miles outside Linnville on the Victoria Road. The little seaport town was situated on Lavaca Bay and served as a port of entry for San Antonio. The citizens of Linnville mistook the war party for a band of Mexican horse traders and were not aware of the danger until Buffalo Hump formed his warriors into a half-moon arc and led a screaming attack. As they neared the town, the Comanches killed a settler and his two slaves. There was little time for the bewildered inhabitants to do anything except flee for the safety of the boats anchored in the bay. Some found refuge on the steamer *Mustang* lying just offshore or rowed to safety in small boats, but others were cut down and scalped before they reached the water. Those who did manage to escape were forced to watch helplessly as their homes and businesses were looted and burned.

The Comanches spent the day pillaging and burning Linnville. Warehouses packed with goods destined to be shipped to San Antonio were a special delight for the looters. Warriors dressed themselves up in top hats and fancy frockcoats—some even paraded in women's dresses and petticoats, the tails of their war ponies braided with a rainbow of ribbons and entire bolts of cloth streaming out behind them as they galloped back and forth through town. One citizen was so distraught and angry at the ransacking that he waded ashore waving an old muzzle-loading shotgun above his head and challenged the warriors to meet him in combat. The bewildered Comanches, thinking that the man must be crazy and therefore untouchable, simply rode around him and acted as if he did not exist. When the man finally gave up and waded back out to his boat he discovered that his shotgun had never been loaded.

Satisfied that the Comanche blood spilled by the Texans during the Council House fight was fully avenged and all debts had been paid, Buffalo Hump called for a return to the Comancheria. However, as heavily burdened as the Comanches were with dozens of fully loaded pack mules, many prisoners and well over two thousand stolen horses, the trail home would prove to be treacherous. At that very moment, riders were galloping all over central Texas drawing men from Lavaca, Gonzales, Goliad, Victoria, Cuero, Bastrop, San Antonio and Austin and from hundreds of widely scattered homesteads. A militia company under the command of Captain Tumlinson pressed the "savages" hard from the rear using hit-and-run tactics while frontier leaders like veteran Indian fighter Matthew "Old Paint" Caldwell, Ben McCulloch and Edward Burleson gathered a band of volunteers on the banks of Plum Creek near present-day Lockhart.

If Buffalo Hump had led the Comanches south of San Antonio on the return ride, they might have escaped the trap set for them by the Texans, but the warriors instead continued to ride northwest—straight into impending disaster. The number of volunteers arriving at Isham Goode's cabin near Plum Creek grew steadily during the night of August 11, and by the following morning more than one hundred volunteers were present, with Colonel Edward Burleson and his contingent from Bastrop due to arrive at any minute. "Old Paint" Caldwell was elected by the volunteers to take command but turned it over to militia general Felix Huston when the general arrived from Austin. The men grumbled in protest because of Huston's lack of experience in dealing with Indians, but Caldwell insisted, and the men went along. Scouts sent out during the night returned around daylight and reported that the Comanches were several miles down the creek raising a considerable cloud of dust as they moved in the direction of the Texans' encampment.

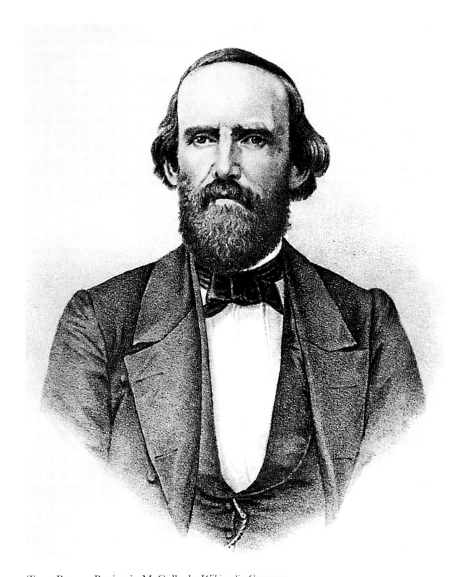

Texas Ranger Benjamin McCulloch. *Wikimedia Commons.*

General Houston ordered the men to mount, and they forded to the west bank of Plum Creek on Goode's Crossing, following the creek until they reached a small clearing concealed from the open prairie by a dense line of timber. Two scouts soon arrived with word that Colonel Burleson, with his eighty-seven volunteers and thirteen Tonkawa scouts, was only a few miles off and advancing fast. When the circus-like cavalcade came into full view

Looking out from the trees along Plum Creek at Comanche Flats in Lockhart, Texas, where the skirmishing began. *Photo courtesy of Jeffery Robenalt, February 2011.*

of the hidden rangers, the Comanches created an awesome spectacle as they slowly made their way across the open prairie to the west of Plum Creek. The warriors and their horses, said one volunteer, were decorated with "fluttering ribbons streaming in the breeze and other gaudy appendages of savage finery." Another volunteer stated:

> *There was a huge warrior who wore a stovepipe hat, and another one who wore a fine pigeon-tailed cloth coat buttoned up behind. They seemed to have a talent for finding and blending the strangest, most unheard-of ornaments. Some wore on their heads immense buck and buffalo horns. One headdress…consisted of a large white crane with red eyes.*

By the time Burleson's men reached Plum Creek, the Comanches had moved a mile or so past the volunteers' position in the trees. As soon as the Texans advanced through the screen of trees and onto the open prairie, they were spotted by the Comanches, who immediately formed a defensive

Kelly Springs, the site of the Battle of Plum Creek. *Photo courtesy of Jeffery Robenalt, February 2011.*

line at the rear of their long column to protect their stolen livestock and plunder. For the next few miles, a running skirmish occurred across the open prairie, with the Texans relentlessly closing in. As they approached the wooded area surrounding Kelly Springs, the Comanche warriors took up a defensive position and awaited the Texans' attack while the women and children continued to drive the stolen hoses and mules to the northwest. The Texans advanced to within 150 yards, at which time General Houston ordered them to dismount and form a "hollow square." The volunteers expected to immediately charge into the middle of the warriors and were shocked by the order to dismount.

While the Texans formed their square, twenty or thirty warriors circled the formation and fired arrows from a distance of sixty to eighty yards. The warriors continued to circle the Texans for the next thirty minutes, making an occasional mock charge until a few men noticed that a prominent war chief raised his shield every time he turned his mount. The next time the chief charged in and raised his shield, several volunteers took aim with their long

rifles and fired. The accurate volley knocked the Comanche off his horse. Wails of distress went up as one by one the warriors bravely risked their lives to recover the war chief's body. "Old Paint" Caldwell looked to General Huston: "Now general is your time to charge them! They are whipped."

Screaming their own battle cries, the Texans spurred their mounts into the middle of the disorganized warriors, long rifles and horse pistols blazing. The Comanches were scattered by the force of the assault, and the Texans killed every warrior they rode down. The struggle was close and cruel, and a running fight ensued for the next fifteen miles, but the fighting heart had been cut from the Comanches, and the day became more of a massacre than a battle. Before the fighting ended, more than eighty Comanche bodies lay along the fifteen-mile battlefield. Only one Texan was killed in the struggle, but many of the white prisoners taken by the Comanches were put to death before they could be rescued.

The Battle of Plum Creek punished the Comanches severely. By banding together in such great numbers, the warriors had tried a new and unaccustomed form of warfare, and they failed miserably. Never again would the Comanches attack a town in force or raid so deep into Texas. Instead, they resumed their old form of guerrilla tactics that continued to prove formidable. President Lamar was now convinced that the Comanches must be taught a lesson for their effrontery, and he ordered Colonel John Moore to lead a retaliatory attack on a winter village far up the Colorado. Under the leadership of Colonel Moore, the Texas Rangers would carry the fight deep into the heart of the Comancheria.

Chapter 12

THE EXPEDITION OF COLONEL JOHN MOORE

Attack on a Comanche Winter Village

In the aftermath of the Great Comanche Raid of 1840 and the Battle of Plum Creek, President Mirabeau Lamar was convinced that the depredations of the Comanches would continue unless the savages were thoroughly chastised and taught that such hostile conduct on their part would no longer be tolerated. To accomplish this difficult mission, Lamar enlisted the services of Colonel John Moore, ordering him to organize an expedition to attack and destroy a Comanche winter village on the upper reaches of the Colorado River. If an entire village could be set afoot and left without the necessary foodstuffs to survive the winter, the action would clearly demonstrate to the Comanches that there was no safe haven for their families as long as they failed to keep the peace.

Colonel Moore had led a similar expedition to Spring Creek in the valley of the San Saba River during the previous February. Unfortunately, after an initial success, the attack on the Comanche village ended in disaster when Moore ordered an unexpected retreat. In his after-action report, the colonel stated that the retreat had been necessary because of poor visibility and the need to reload weapons; however, many of the volunteers did not agree with Moore's assessment. Chief Castro went so far as to withdraw his Lipan Apache scouts from the expedition and set out for home. To make matters worse, the Comanches conducted a well-planned midnight raid on the ranger encampment and ran off with half of Moore's horses, forcing many of his men to return to Austin on foot. Moore was determined that such a disaster would not occur again.

Moore posted circulars and placed advertisements throughout the small towns and widely scattered homesteads of central Texas to recruit the men he needed. In light of all the burning and killing the Comanches were responsible for on the frontier, he was not surprised when his efforts brought a prompt response. By early October, close to ninety volunteers—mostly from Fayette and Bastrop Counties—gathered at Walnut Creek near the new capital of Austin. Having crossed over much of the same rugged hill country terrain on his previous expedition, Moore decided to use pack mules instead of wagons to carry the expedition's supplies. He also trailed a small herd of cattle behind the string of pack mules to serve as a mobile commissary and avoid the unwelcome attention the need for hunting might bring.

On Monday, October 5, the expedition, led by Chief Castro and seventeen Lipan Apache scouts, departed from the camp on Walnut Creek and headed north toward the San Gabriel River. Bearing west at the San Gabriel, the column followed the river's course to its headwaters and then moved cross-country to the Colorado River, thus avoiding the worst of the hill country. After fording the Colorado, the volunteers continued northwest, crossing both the San Saba and Llano Rivers. Throughout the expedition's route, the Lipan scouts spread out, thoroughly scouring the countryside for any sign of the Comanches, but none was found. Undaunted, the expedition pushed farther to the northwest. Moore was one of the first white men to travel so deep into the western reaches of the Colorado River, and in his later report, he stated that he "found the country rich and beautiful, abundant in game, and covered with a waving sea of grass broken only by occasional rivers and canyons, with tremendous vistas."

As the expedition drew closer to the Concho River, a "blue norther" storm unexpectedly rolled in, and the weather took a severe turn for the worse. Torrential freezing rain and near-gale-force icy winds plagued the trail, and it was impossible for the volunteers to stay dry in the miserable conditions. A number of men fell ill as the column continued to plod on through miles of deep clinging mud and standing water. A young volunteer, Garrett Harrell, drowned while the expedition forded the raging floodwaters of the Concho, and Colonel Moore began to grow discouraged after so many days on the trail with no sign of the Comanches and little letup in the dangerous weather. He reluctantly ordered the column to follow the Concho back to its confluence with the Colorado, where he planned to return to Austin if nothing turned up and the weather conditions failed to improve.

However, the rain abated somewhat as the expedition drew closer to the Colorado. More importantly, the Lipan scouts found tracks of a large

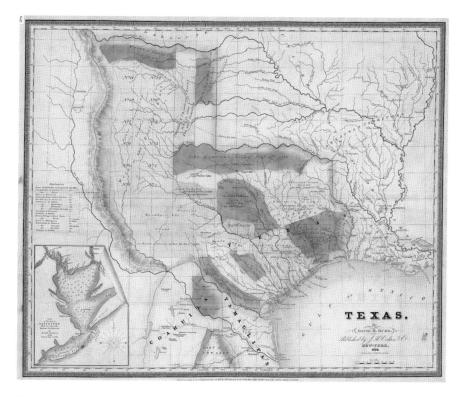

Texas, 1834. Engraved by S. Stiles. *Courtesy of Texas State Library and Archives Commission.*

number of unshod horses mixed in with the drag marks of many travois and the footprints of women and children—clear signs of a village on the move. The volunteers followed the tracks northwest along the Colorado and on October 23 discovered a large grove of pecan trees where the Comanches had stopped to gather nuts for the winter. Most of the pecans had been harvested, and with such a heavy load to carry, the scouts were sure the encampment was not far off. After ordering the men to take cover in a brushy thicket on the reverse side of a hill sheltered from the icy blast of the north wind, Colonel Moore called on his two best scouts to ride ahead. Departing at mid-morning, the Lipans did not return until near sundown, but they brought welcomed news. The Comanche village was located on a horseshoe bend of the Colorado less than twenty miles upriver.

The news of the discovery energized the volunteers. In spite of the miserable weather, they were eager for an engagement. After a cold supper, Colonel Moore led the column ten miles up the Colorado, where the men

secured their small herd of cattle in a mesquite thicket near the river and continued on for a few more miles. Halting the march at midnight, Moore ordered the men to dismount and rest their horses while he dispatched the same two Lipan scouts to determine the exact location of the village and gather an estimate of the Comanches' strength. The Lipans returned a few hours before sunrise and reported that the village was only four miles upriver on the south bank of the Colorado, with sixty to seventy lodges and an estimated 125 warriors. The column continued its advance for another two miles, where they secured their pack animals in a wooded hollow and waited for the command to advance.

Near sunrise on October 24, Colonel Moore gave the long-awaited order to mount. As the volunteers approached the sleeping village, Lieutenant Clarke Owen, recently arrived at Austin from Mississippi, was ordered to ford the Colorado below the camp with the Lipan scouts and deal with any Comanches who managed to make it across the river. Captain Thomas Rabb from La Grange and his men would form up on the right, Captain Nicholas Dawson from Bastrop and his men would be on the left and Colonel Moore would ride with the Owens's men and command from the center.

The volunteers moved to within two hundred yards of the encampment without detection and slowly went on line. Only the fog-muted jingle of harness and the soft squeaking of saddle leather disturbed the deathly silence of the early morning. When all was in readiness, Colonel Moore gave the signal and the entire command started forward at a walk, quickly moved into a trot and finally broke into a thundering gallop. The Comanches were taken by surprise, stumbling out of the snug warmth of their buffalo robes only to be greeted by the howling screams of the rangers and the hammer-like pounding of countless hooves. Nearly naked and mostly weaponless, the Indians fled for the perceived safety of the ford on the Colorado River.

The volunteers brought down a punishing hail of gunfire on the retreating and confused Indians as they galloped into the village unchallenged. Halfway through the scattered buffalo-hide lodges, Moore called for the men to rein in so they could dismount and reload. After quickly reloading, the volunteers continued to fire until the barrels of their long rifles were smoking hot. Many Comanches were killed before they reached the Colorado, and a large number of others were brutally gunned down as they attempted to flounder across the ford, their bodies swirling away with the current. The volunteers advanced to the river in an orderly fashion and continued to fire at the fleeing Indians, hitting many of them as they emerged from the river on the opposite bank. The few Comanches fortunate enough to run the

deadly gauntlet of fire from the village and safely reach the far bank fled across the open prairie only to be ridden down by Lieutenant Owens and the Lipan scouts.

The scene was one of carnage. Bodies of dead, dying and wounded Comanche men, women and children lay sprawled across the village and both banks of the Colorado. Though an honest effort was made by most of the rangers to spare the lives of the women and children, a good number of them were killed or wounded in the confusion of the fight. Colonel Moore later reported that forty-eight Comanches were "killed upon the ground, and eighty killed and drowned in the river." Many of the volunteers believed this estimate was too low. Thirty-four Comanche prisoners were taken during the fight. None of the Texans was killed, and only two suffered minor wounds.

The victory on the Colorado was the most severe punishment the Comanches had ever received at the hands of the Texans. In addition to the numerous casualties and prisoners the Indians suffered, all the property and food in the village was either confiscated or destroyed, including much of the loot carried away from the raid on Victoria and Linnville. More than five hundred Comanche horses were also rounded up.

The volunteers returned to Austin on November 7 with the welcomed news of their victory. The grateful citizens of the capital held a dinner and celebration in their honor. The power of the southern Comanche was forever broken. Though they remained a nuisance, they were never able to fully recover from the results of the devastating defeat on the Colorado and the crippling losses they suffered at the Council House fight and Plum Creek. However, the Texans and the Comanche bands from the far northern reaches of the Comancheria had not yet come into meaningful contact, and the struggle for control of the western frontier would continue for many more years.

Chapter 13

LAMAR'S "WILD GOOSE" CAMPAIGN

A Failed Attempt to Annex Santa Fe

The Treaties of Velasco were signed by Mexican president General Antonio Lopez de Santa Anna in the aftermath of the Battle of San Jacinto. The public treaty dealt mainly with the disengagement of forces, but the key provision of the secret treaty stated that the territory of the Republic of Texas would not extend beyond the Rio Grande. Mexico had long claimed the Nueces River as the boundary between Texas and itself, but President Mirabeau Lamar interpreted this controversial treaty provision to mean that not only was the border between Texas and Mexico the Rio Grande but also the border ran the entire length of the river—from the Gulf of Mexico to the far northern foothills of the Rocky Mountains.

Under this view, the long-established settlement of Santa Fe and half the province of New Mexico fell within the territory of Texas. Gaining sovereignty over New Mexico would promote President Lamar's goal of westward expansion, but even more importantly it would provide the nearly destitute Republic of Texas with a source of revenue. A thriving system of commerce had developed between the United States and Mexico after Mexico gained its independence from Spain in 1821 and opened the Santa Fe Trail to free trade. Lamar, desperate for a new source of income, wanted Texas to take control of this profitable enterprise.

In 1841, President Lamar sought congressional approval to send an expedition to New Mexico. However, when the Texas Congress refused his request, the president proposed to send the expedition on his own initiative—ostensibly to establish a trade route across the barren reaches

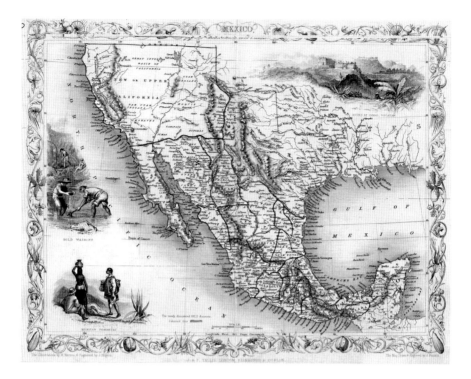

Mexico, California and Texas, circa 1849. Engraved by J. Rapkin and illustrated by J. Warren and J. Rogers. *Courtesy of Texas State Library and Archives Commission.*

of northern Texas to Santa Fe and to offer the citizens of New Mexico an opportunity to voluntarily join the republic. Of course, it was rumored that should the Mexicans unwisely refuse such a generous offer, force could always be applied if and when the opportunity presented itself.

A call for volunteers was issued, and adventurers gathered from all parts of the republic, eager to harvest the gold and silver that was said to lie in the streets of Santa Fe for the taking. In addition, any merchant willing to ship his goods to Santa Fe was promised both transportation and protection for his merchandise. The 270 volunteers designated to protect the trade caravan and act as an invasion force if the situation called for it were commanded by General Hugh McLeod, with George Thomas Howard as second in command. The men were organized into five infantry companies and an artillery company. Captain Matthew "Old Paint" Caldwell, fresh from the victory at Plum Creek, commanded one of the companies. Supplies for the expedition and the merchants' trade goods were carried in twenty-one ox-drawn wagons.

The expedition, or what Andrew Jackson referred to as "the wild goose campaign to Santa Fe," set out on June 19, 1841, from a site on Brushy Creek fifteen miles north of Austin. With the oxen slowly plodding north, the Texans took nearly a month to ford the Brazos River and enter the Cross Timbers in the area of present-day Parker County on July 21. That was only the beginning of the agony. Cutting their way through the thickets and underbrush of the Cross Timbers and hauling the wagons across numerous gullies and dry washes was backbreaking labor, and the men constantly suffered from the intense heat and lack of water.

Continuing their struggle in a northwesterly direction, the ox-drawn wagons slowly cleared the Cross Timbers and reached the present-day site of Wichita Falls. At the falls, the Texans received little help from their sullen Mexican guides and mistakenly believed that they had reached the Red River. They followed the course of the Wichita for nearly two weeks before finally taking note of their error. By then, the practically useless Mexican guides had deserted the expedition entirely, and McCleod was forced to send a company of men north to search for the Red River. A guide returned on August 20 to lead the wagons to the northwest.

Constantly harassed by hit-and-run raids of Comanche and Kiowa war parties and suffering from a lack of adequate provisions and a scarcity of water, the expedition continued to plod slowly to the northwest until reaching Quitaque Creek in the northwestern corner of present-day Motley County. In front of them stood the imposing Cap Rock, a tall, abrupt escarpment rising nearly two hundred feet from the rolling plains of north central Texas. Above the towering ridge stretched the dreaded Llano Estacado, the infamous "Staked Plains" so named nearly three hundred years before by conquistador Francisco Coronado during his fruitless search for the fabled "Seven Cities of Gold."

Unable to locate a trail by which the wagons could ascend the Cap Rock, McLeod sent a mounted party out to seek the settlements of New Mexico while he and the remainder of the expedition waited below the escarpment. After suffering numerous hardships, the advance party finally met up with some Mexican traders on September 12 and sent a guide back to lead the wagons to the top of the Cap Rock and across the desolate high plains. Unfortunately, the brutal journey was far from over. The rugged terrain of the Staked Plains, cut by hundreds of deep arroyos and bone-dry washes, slowed the movement of the expedition's wagons to a crawl. Water was so scarce along the route that the Texans were constantly thirsty, and the expedition repeatedly wandered off course because not one man in the

The falls of Wichita River, Wichita Falls, Texas. *Wikimedia Commons.*

The Llano Estacado Caprock Escarpment south of Ralls, Texas. *Wikimedia Commons.*

entire outfit was familiar enough with the vast treeless plains to realize when the Mexican guide was making a mistake.

Finally, after suffering for nearly 1,300 miles since their departure from Austin, the Texans staggered into New Mexico, their spirits broken, their bodies lean from hunger and practically dying of thirst. The volunteers had naively expected to be welcomed with open arms by the citizens of New Mexico, but instead the ill-fated expedition was met at the border by a force of 1,500 Mexican dragoons under the command of Manuel Armijo, the Santa Anna–appointed governor of New Mexico. The governor offered the Texans fair treatment and clemency if they would agree to surrender their weapons. After the arduous journey from Austin, the volunteers were in no condition to fight a force that outnumbered them so heavily, so with little choice, they surrendered. Thus, without firing a single shot, the entire expedition passed into Mexican hands. Of course, once Armijo had possession of the Texans' weapons, he promptly reneged on his promise, and the Texans were immediately bound by hand and foot.

That evening, Governor Armijo called for a conference of the Mexican officers to determine whether the prisoners would be executed immediately or sent to Mexico City. After a long discussion with much heated debate on both sides of the issue, a vote was taken. The volunteers' lives were spared by a scant majority of one vote. The expedition's wagons and trade goods were confiscated, and the governor ordered that the Texans be marched in chains the entire 1,500 miles to Mexico City.

During the brutal, tortuous journey, the Texans were subjected to many indignities. The men, already weakened from their terrible ordeal, died of thirst, hunger and exhaustion or the occasional musket or pistol ball to the back of the head. Those who were fortunate enough to survive the death march arrived in Mexico City on December 26 and were immediately put to work as slave laborers repairing roads. Like most Texans taken prisoner by the Mexicans, the unlucky members of Lamar's "Wild Goose" campaign eventually found their way into the dank dungeons of Perote Prison in Vera Cruz.

When word of the debacle reached Texas, people were furious, and many of them rightfully put the blame squarely on the shoulders of President Lamar. A letter in an Austin newspaper in January 1842, most likely written by enemy of Lamar and future president of the republic Anson Jones, proposed that Lamar be exchanged for the Santa Fe prisoners. Of course, Lamar avoided this fate, and the prisoners continued to languish in Perote Prison until diplomatic efforts of the United States secured their release in April 1842.

The Santa Fe debacle was the political Waterloo for President Lamar. Hope for continued peace with Mexico had practically vanished, the currency had fallen to three cents on the dollar and public debt had risen to more than $6 million. Sam Houston soon returned to the presidency of the republic with a plethora of problems to solve, not the least of which was a series of incursions across the Rio Grande by Mexican soldiers in retaliation for Lamar's ill-fated Santa Fe expedition.

Chapter 14

THE BATTLE OF THE SALADO

A Mexican Incursion and the Occupation of San Antonio

In March 1842, Mexican president Santa Anna retaliated in response to President Mirabeau Lamar's ill-fated "Wild Goose" campaign by ordering General Raphael Vasquez and more than one thousand soldiers across the Rio Grande with orders to occupy San Antonio. The border incursion caught the Texans by surprise, but fortunately the Mexican forces under Vasquez remained in San Antonio for only two days before they withdrew and marched back to the Rio Grande, their wagons piled high with plunder.

Captain Jack Hays and his Texas Rangers dogged the Mexicans on the march back to Laredo, but his small force lacked the strength to do anything except harass the column. Angered by General Vazquez's flagrant violation of the border, the Texas Congress passed a declaration of war against Mexico, but the current president, Sam Houston, knowing full well how ill-prepared the bankrupt Republic of Texas was for war, wisely vetoed it. "Texas would defend itself if need be," he declared, "but we must not attack."

Relations between Texas and Mexico remained at an uneasy standstill until Santa Anna made the decision to break the impasse and ordered French mercenary General Adrian Woll to cross the border with 1,200 soldiers and again advance on San Antonio. To Santa Anna, this incursion was not meant to be a formal act of war but merely a demonstration in force to accomplish three goals: to assert Mexican sovereignty across the Rio Grande, to chastise the Texans for their move on Santa Fe and to let the expansionists in the United States know that Mexico was prepared to act in the protection of its own interests.

Statue of John Coffee "Jack" Hays at the Hays County Courthouse, San Marcos, Texas. *Photo courtesy of Jeffery Robenalt, Texas Escapes Online Magazine, February 2011.*

General Woll cleverly avoided the Texas Ranger scouts Captain Hays posted south of town by leaving the main road and making an extended night march through the hills, capturing San Antonio well before dawn on September 12. Like General Vasquez, Woll planned to occupy San Antonio for only a few days, but he made good use of his time by capturing the members of the district court (which happened to be in session) along with a number of other prominent Texans. With only a small force of rangers, Hays could do nothing except dispatch his men across the countryside to gather the militia.

The rangers sent out the call, and from all across central Texas individuals and small groups of men rode or walked to the relief of San Antonio. Soon more than two hundred volunteers gathered at Seguin, every man ready and eager to drive the Mexicans out of the republic. The volunteers cheered when Matthew "Old Paint" Caldwell, a recently released prisoner from the Santa Fe expedition, galloped into town at the head of a strong detachment of volunteers from Gonzales and the

Guadalupe Valley. The well-known Indian fighter was immediately elected to the rank of colonel and given command of the small Texas army. Jack Hays was selected to lead the forty-two-man mounted detachment, most of them men from his own ranger company.

By midnight on September 17, Colonel Caldwell and his 210 volunteers were encamped on the east bank of Salado Creek six miles northeast of San Antonio, not far from the site of present-day Fort Sam Houston. A natural earthen embankment on the east side of Salado Creek and a good stretch of timber provided the volunteers with excellent cover. From behind the embankment, there was a clear field of fire into a wide grassy prairie that rose gently from the creek to a low ridge nearly eight hundred yards away. Anyone foolish enough to approach the creek across the open prairie would be fair game for the accuracy of the Texans' long rifles. To the rear of the position, a steep, heavily thicketed ridge rose from the far bank of the creek, rendering an approach from the west practically impossible.

However, no matter how secure their position, most of the volunteers were eager to abandon the creek and launch an attack on San Antonio. Fortunately, Caldwell realized his small force could never hope to drive General Woll and his 1,200 soldiers out of the Alamo. The only answer was to somehow lure Woll into attacking the Texans across the open ground from the east, where their expert marksmanship could be put to best advantage. After careful consideration of the situation, Colonel Caldwell came up with a plan. Early the following morning, he sent Jack Hays and a few of his rangers to the Alamo. Following Caldwell's orders, the rangers rode along the mission's walls shouting insults to the guards and challenging the Mexicans to a fight. Suddenly, Mexican bugles blared and a troop of lancers galloped out of the compound in hot pursuit of their tormentors.

Fleeing toward the Salado, the rangers splashed across the creek a mile above Caldwell's camp and reached the safety of the Texas lines well before the Mexican cavalry reined up on the low ridge to the east. After a brief rest for the horses, Hays led his rangers in a series of skirmishes with the lancers. Putting their few Colt Paterson revolvers and muzzle-loading shotguns to good use when the fighting became close, the rangers managed to kill ten Mexican cavalrymen and wound twenty-three before returning to the creek without suffering a casualty.

Early in the afternoon, General Woll arrived on the ridge east of Salado Creek at the head of 400 infantry, 160 dragoons and two pieces of artillery. The guns were immediately brought forward and unlimbered. Soon they were banging away at the Texas positions along the creek, shells screaming

Salado Creek, San Antonio, Texas. *Photo courtesy of Jeffery Robenalt, March 2011.*

in at regular intervals. The barrage did little damage, but Caldwell was thankful that General Woll left most of his artillery in the Alamo. A sustained bombardment from all of Woll's guns may well have driven the Texans away from the protection of the creek bank, and the inexperienced volunteers were ill prepared to confront the well-trained Mexican troops in the open.

While the laborers conscripted into Woll's service were busy setting up a huge pavilion-like tent to shield the general and his staff from the broiling rays of a merciless Texas sun, the Mexican drummers began to beat a steady tattoo of commands. Responding to the beat, the Mexican infantry formed four long lines of battle facing the creek, with a thin line of skirmishers well to the front and the dragoons in the rear to act as a reserve. Cavalry served as a screen for each flank. General Woll was now prepared for what he thought would be an easy victory.

For the next two hours, Colonel Caldwell was content to send out fifteen to twenty skirmishers at a time to mix it up with the Mexican skirmishers. He hoped to lure General Woll into launching an all-out attack across the open prairie before the Frenchman decided to send for more artillery. Time

passed slowly, and still Woll refused to take the bait. During this lull, two riders bearing bad news suddenly burst through the Mexican lines on well-lathered horses and reined up in front of Caldwell, nearly shouting their breathless message.

Responding to "Old Paint's" earlier calls for assistance, a detachment of fifty-three volunteers out of La Grange, under the command of Captain Nicholas Dawson, had been cut off and surrounded several miles from Salado Creek. After an unsuccessful cavalry charge, the Mexicans stood off and shelled the unlucky Texans with artillery until the battered volunteers raised a white flag and laid down their arms. Ignoring pleas for mercy, the Mexican troops moved in and bayoneted the wounded and many of the others, taking few prisoners.

Word of the atrocity quickly flashed up and down the Texas lines, and many of the furious volunteers demanded an immediate attack on the Mexicans. Wisely disregarding the rumblings of the discontent, Caldwell continued to bide his time. The veteran Indian fighter's patience was finally rewarded when General Woll took the bait. Once again the drums began their steady beat as the Mexican officers drew their swords and signaled the infantry and dragoons to advance across the open prairie.

The outcome of the battle was exactly what Caldwell had hoped for. The Mexicans marched forward to the beat of their drums as if on parade while bayonets glistened in the late afternoon sun. The Texas marksmen concealed behind the cover of the earthen embankment delivered volley after volley of devastatingly accurate rifle fire into the enemy's massed ranks. Mexican soldiers fell by the score, most of them hit in the head or center-punched in the chest. One Texan remarked that the fight "was an easygoing affair" and "seemed like child's play."

Toward sunset, General Woll, now thoroughly cowed by the pinpoint marksmanship of the Texas volunteers, reassembled his battered troops and ordered a hasty retreat to San Antonio. During the brief encounter, only 1 Texan was killed. The Mexicans left 60 bodies on the battlefield and filled their wagons with another 44 dead and 150 wounded. The following day, the Mexicans held a mass funeral in San Antonio rather than the grand victory fandango they had planned earlier.

General Woll's troops evacuated San Antonio on September 20, taking a herd of five hundred cattle and whatever wagons and carts they could lay their hands on piled high with plunder. Two hundred Mexican families, seeking protection from the town's enraged Anglo citizens, accompanied the column. Caldwell called a council of war, and a vote was taken. Thanks to

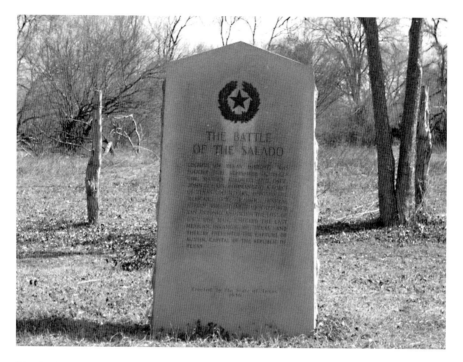

The Battle of the Salado historical marker, San Antonio, Texas. The inscription reads: "The Battle of the Salado, decisive in Texas history, was fought here, September 18, 1842. Col. Matthew Caldwell and Capt. Jack Hays, commanding a force of Texas volunteers, opposed the Mexican Army under General Adrian Woll that had captured San Antonio and, with the loss of only one man, checked the last Mexican invasion of Texas and thereby prevented the capture of Austin, capital of the Republic of Texas." *Photo courtesy of Jeffery Robenalt, March 2011.*

the persistence of Jack Hays, it was decided to pursue the Mexicans and launch an attack if possible. Hays and his Texas Rangers led the pursuit, catching up with the Mexican rear guard near the Arroyo Hondo in mid-afternoon on September 22. By then, Woll's main column had crossed the river and assumed a good defensive position along the west bank. Only a company of infantry and a few cavalry remained on the east bank to protect two cannons and the Mexican families who had not yet crossed.

Caldwell gave Captain Hays permission to assault the Mexican guns and promised to support the attack with his infantry. Led by Hays, the rangers made a valiant mounted charge into the face of the Mexican cannon, killing all five artillerymen as they galloped past. However, Caldwell failed to support the effort as promised, and a determined advance by the Mexican infantry forced the rangers to spike the guns and withdraw under heavy

fire. Jack Hays was furious with Caldwell, but fearing the Mexican cannon, the volunteers had simply refused to advance on the strong position along the river. There was nothing the veteran militia leader could have done to make them move. General Woll led his tired and badly bloodied force away from the river during the night and reached the safety of the Rio Grande on October 1. Refusing Caldwell's order to withdraw, Hays and the rangers dogged Woll's column all the way back to the border, occasionally skirmishing with the Mexican cavalry.

Although Hays and his rangers were disappointed with the outcome of the Battle of the Salado, they received welcomed news upon their return to San Antonio. Finally bowing to the growing tide of political pressure, President Sam Houston ordered General Alexander Somervell to organize an expedition to conduct a patrol in force along the Rio Grande. The patrol was granted authority to cross the border if Somervell deemed it necessary. At long last, the Texas Rangers would have their opportunity to take the fight to Mexico.

Chapter 15

THE MIER EXPEDITION

A March into Hell

In the aftermath of President Mirabeau Lamar's ill-fated expedition to Santa Fe, his successor, Sam Houston, did his best to maintain what had become an uneasy peace between Mexico and the Republic of Texas. President Houston even cautioned peace when Mexican dictator Santa Anna retaliated by sending General Vazquez with one thousand troops across the Rio Grande to occupy San Antonio. An infuriated Texas Congress declared war on Mexico, but Houston wisely vetoed the declaration. However, an incident that occurred during the fighting at Salado Creek finally forced President Houston's hand. In response to Caldwell's call for volunteers, Captain Nicholas Dawson and fifty-three volunteers from La Grange and Fayette County attempted to fight their way to Salado Creek through numerous Mexican cavalry patrols.

Eventually, the Texans were cut off and surrounded only a few miles from the creek, where they dismounted and took cover in a mesquite thicket near the present site of Fort Sam Houston. The Texans repulsed an initial cavalry charge, but the Mexicans stood off and used their artillery to batter the volunteers into submission. Ignoring any attempts to surrender, the Mexicans moved in and finished off the wounded with bayonets, taking few prisoners. In what was to become known as the Dawson Massacre, thirty-six Texans were killed, fifteen were taken prisoner and two escaped to reach Caldwell with the news. The few prisoners were marched to Mexico City and then to Perote Prison in Vera Cruz.

Finally, on October 3, 1842, President Houston, bowing to the inevitable, ordered General Alexander Somervell of Matagorda County to take

command of the militia and Texas Rangers he called to muster in San Antonio. However, Houston wisely hedged on an all-out invasion of Mexico when he gave General Somervell orders to make a demonstration in force along the border and to "only cross the Rio Grande if he thought it could be done successfully."

On November 7, 750 volunteers assembled at Mission San Jose in San Antonio. The first task facing General Somervell was to move his small army to a camp on the south bank of the Medina River and organize the men into regiments and companies of infantry. Unlike the force Caldwell commanded at Salado Creek that was made up of local militia and a few Texas Rangers fighting to protect their families and homes, many of Somervell's undisciplined adventurers had been lured from afar with rumors of loot and promises of glory. The Texas Rangers commanded by Jack Hays were clearly an exception. They would prove to be an invaluable asset to the general during the trying times that lay ahead.

On November 25, the rangers led the way south from the camp on the Medina, their homemade flag proudly bearing the motto "We Give But Ask No Quarter" hanging limp in the pouring rain. The expedition was short on powder, lead, beef, bread and most other supplies. The small army even lacked the wagons necessary to carry what little it did have. The lack of wagons, however, proved to be a blessing in disguise because rain had been falling for several days and the land that stretched between the Medina and the Frio Rivers was a virtual quagmire.

Three weary days later, after slogging through miles of mud and standing water, the column reached the Laredo Road and eventually forded the wide but shallow Frio River on December 1. The raging floodwaters of the Nueces came next. When the rangers rode ahead to scout Laredo, they were forced to undress and hold bundled clothes and weapons high over their heads while their horses swam against the strong current. Without the aid of a horse, swimming the river was next to impossible, so Somervell ordered the construction of a crude bridge. The river was quickly spanned, and the volunteers were waiting on the south bank of the Nueces when the rangers returned from their scout three days later.

General Somervell was surprised when Hays reported that Laredo was undefended, and he immediately ordered a forced march to the Rio Grande. By daybreak on December 8, the Texans were encamped in a semicircle around Laredo. Unfortunately, hours earlier the alcalde of Laredo had ordered more than one thousand horses driven across the river out of the Texans' reach. Somervell's hope of mounting his entire force was lost. The

Texans received a silent greeting from the citizens of Laredo when they entered town later that morning. Jack Hays personally hoisted the Texas flag to the top of the church steeple. After demanding supplies from the alcalde, Somervell pulled his men out of town and relocated them three miles south on a hill near the Rio Grande. The remainder of the day passed without incident, but well before sunrise the following morning, more than two hundred men slipped out of camp and headed for town.

Ignoring General Somervell's direct orders to the contrary, the rowdy volunteers looted Laredo, taking what they pleased from the terrified citizens, including an occasional unwilling daughter or wife. With the assistance of the Texas Rangers, Somervell was eventually able to clear the town of the undisciplined rabble and return most of the booty. However, much to the alcalde's annoyance, the general kept all of the stolen coffee, flour, sugar and soap.

When the Texans pulled out of Laredo the following day, Somervell decided to march down the east bank of the Rio Grande to avoid the prying eyes of the Mexican cavalry. The decision proved to be costly. Time and again mesquite thickets and thorny chaparral forced the column to circle well away from the river, and often there was no choice except to chop a path through the prickly undergrowth. After six miserable days, the volunteers were exhausted, hungry and practically out of supplies. That evening, nearly two hundred men voted to return to San Antonio.

The following morning, the remaining Texans crossed the Rio Grande and advanced to Guerrero some sixty miles below Laredo. There Somervell gave the alcalde an ultimatum: either hand over one hundred horses and five days' provisions or the town would be sacked. The Texans retreated back across the river to await the delivery of the horses and supplies, but when the alcalde failed to meet his demands in the morning, Somervell realized little could be gained by sacking Guerrero. Whether they liked it or not, his men were relatively safe on the Texas side of the Rio Grande, and he intended to keep them there.

On the morning of December 19, General Somervell made a reluctant decision to abandon the entire mission. The expedition would march north to Gonzales, where it would be disbanded. As Somervell had expected, many of the men were furious with his decision. William S. Fisher, one of the expedition's captains, asked for permission to continue the march down the river with those men who were unwilling to disband, but Somervell denied the request, warning of the dangers in such a move. Ignoring the general's warning, 305 volunteers promptly resigned from his command and elected Fisher to lead them in a private invasion of Mexico—in actuality more of a

quest for revenge and plunder than a military action. Jack Hays and most of the Texas Rangers were among the 189 men who departed for Gonzales in the early afternoon, but rangers Sam Walker and Bigfoot Wallace made the decision to stay behind and join Fisher's command.

After consulting with his officers, Fisher dispatched the Texas Rangers who remained with him down the Mexican side of the Rio Grande with the dual mission of screening his force from the prying eyes of the Mexican cavalry and scouting the area around the town of Mier for any sign of the enemy. The newly elected colonel then marched the majority of his small army south along the Texas side of the Rio Grande, ferrying the remainder of the men down the river on boats captured by the rangers during the crossing to Guerrero.

On December 22, the Texans marched into the Mexican town of Mier unopposed. Colonel Fisher met with the alcalde in the main plaza, loudly demanding enough horses to mount his entire force and sufficient provisions to feed the men for a week. As General Somervell had before him, he threatened the town with destruction if the horses and supplies were not delivered to the Texas side of the Rio Grande by morning. But unlike Somervell, Fisher meant to keep his promise. Sensing the sincerity in the bitter tone of Fisher's words, the alcalde agreed to meet his demands, and the Texans returned to their camp across the river.

The Texans were no sooner across the Rio Grande than Mexican general Pedro Ampudia arrived in Mier with three thousand troops and refused to allow the alcalde to deliver the promised supplies. Fisher was furious. Ignoring odds of ten to one against him, he marched the Texans back to Mier on December 24 and launched an immediate attack. The struggle was close and bloody, but the outnumbered Texans fought their way to the main plaza before nightfall.

The following day, General Ampudia ordered three separate suicidal charges across the plaza directly into the muzzles of the Texans' rifles. In spite of being so heavily outnumbered, Fisher's small army held firm until shortages of water, food, powder and lead finally forced them to surrender the following morning. Only thirty-one Texans were killed or wounded during the intense fighting, while the Mexicans suffered two hundred wounded and nearly six hundred killed. In an act of revenge for their terrible losses, the Mexican soldiers stripped the bodies of the dead Texans and dragged them through the streets of Mier.

The survivors were marched in chains to Matamoros and then on to Salado. On February 11, 1843, led by Sam Walker and Bigfoot Wallace, the prisoners managed a mass escape by disarming their guards and overpowering the soldiers guarding the arms and ammunition. Unfortunately, most of the

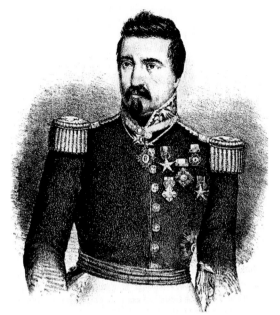

Left: General Pedro de Ampudia, the Mexican commander at Mier. *Wikimedia Commons.*

Below: *The Drawing of the Black Bean* by Frederick Remington. *Wikimedia Commons.*

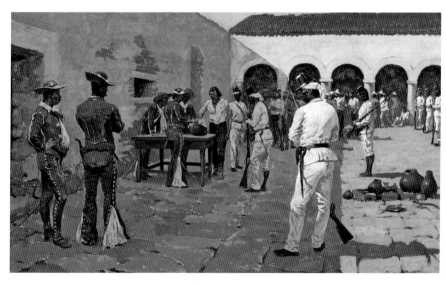

Texans soon became lost, wandering for six days in the mountainous desert north of Salado until they were nearly dead from thirst and hunger. The Mexicans recaptured 176 prisoners and marched them to Saltillo, where Santa Anna sentenced them to death en masse. The harsh sentence was later commuted to death for 1 man in 10 at the urging of the American and

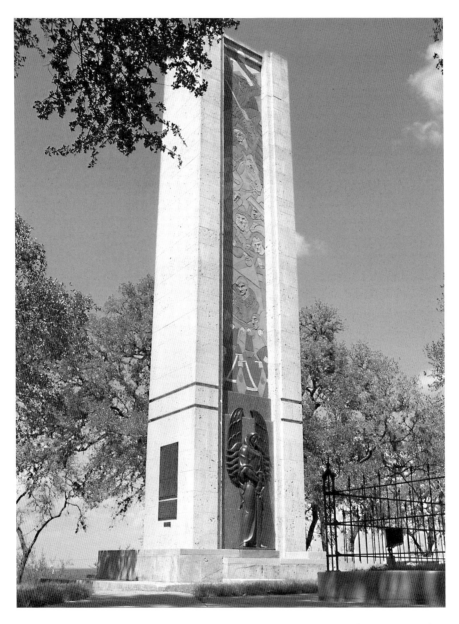

The forty-eight-foot 1936 Centennial Monument marks the mass grave of the remains of the men killed in the 1842 Dawson Massacre and the 1843 Black Bean Episode. *Courtesy of Sarah Reveley, Texas Escapes Online Magazine.*

British ambassadors. In what was to later become known as the infamous Black Bean Episode, the prisoners were forced to draw beans from a jar. The seventeen men who drew black beans were stood against a wall and executed by firing squad.

The remaining prisoners were marched to Mexico City, where they spent the summer laboring in a road gang. In September 1843, most of the Texans were transferred to the infamous Perote Prison in Vera Cruz, though some found their way into other Mexican prisons. Over the course of the next year, a few escaped, including Sam Walker, who made his way to Tampico and managed to board a ship for New Orleans. Many others died of wounds, disease and starvation.

Due to the unceasing diplomatic efforts of the British and American ambassadors, survivors of the long ordeal were finally released on September 14, 1844. The remains of the men executed in the Black Bean Episode were unearthed and returned to Texas in 1848 and buried in La Grange alongside the men killed in the Dawson Massacre. A monument in their honor now stands at the Monument Hill State Historical Site in La Grange, Texas.

Chapter 16

A YUCATAN ADVENTURE

The Rise and Fall of the Texas Navy

In the spring of 1840, the navy of the Republic of Texas was immersed in a political battle between President Mirabeau Lamar and his archenemy, former president Sam Houston, then serving as a member of the Texas Congress. The Houston-led Congress had already dismantled the Texas Army in an effort to curtail Lamar's free-spending expansionist policies. Now it was set on dealing with the Texas Navy in the same manner. In the midst of this acrimonious dispute stepped in twenty-eight-year-old naval first lieutenant Edwin Ward Moore, who was fluent in Spanish and had twelve years' experience serving in the U.S. Navy.

In 1838, a United States squadron of warships—including Edwin Moore's sloop of war *Boston*—anchored in Galveston Bay. Lieutenant Moore, whose brother already resided in Texas, became intrigued with the efforts of the new republic to build a navy from scratch. Since prospects for promotion were dim at best at the time in the U.S. Navy, which was both small and outdated, Moore decided to take a risk and offer his services to the Republic of Texas. In 1839, he resigned his American naval commission and accepted an appointment as commodore of the new Texas fleet. The majority of the other officers who served in the fleet were also recruited from the U.S. Navy.

Newly promoted Commodore Moore's first task was to enlist the sailors and marines required to man the fleet. To accomplish this vital task, Moore traveled to New York, where he set up a recruiting office at the Brooklyn Navy Yard, offering both adventure and prize money for all men who joined the Texas cause. He soon had the seamen he required but returned to Texas

Humboldt Map of Mexico, Texas, Louisiana and Florida. *Wikimedia Commons.*

only to be caught in the political squabble between Lamar and Houston. However, Moore could plainly see that Lamar's proposed mission to Mexico had public support, and being unfamiliar with the highly partisan politics of the republic, he disregarded the strong opposition to his plans by the Houston faction.

Eager to apply pressure to the ongoing secret negotiations between Texas and Mexico, Commodore Moore set sail in June 1840 on the flagship *Austin* accompanied by the steamship *Zavala* and three schooners. Moore had little faith in the peace negotiations, and he was determined to deal a blow to Mexico that would bring the Mexicans to heel and force them to recognize the independence of Texas. In support of this goal, he established a blockade of the Mexican coast off the port of Tampico, stopping all incoming and outgoing ships.

By fall, it was obvious that the peace negotiations had failed, and with the fleet desperately low on food and fuel, Moore was forced to choose between taking action and sailing home. He chose action, sailing the *Austin*, the *Zavala* and the *San Bernard* ninety miles up the Tabasco River to the provincial capital of San Juan Bautista, where he negotiated a deal with the Yucatan rebels, who were locked in a struggle with the Mexican government for their own independence. The agreement called for Moore to assist the rebels in capturing the capital in exchange for $25,000, but when the city fell without a shot being fired, the Texans had to seize two rebel ships and hold them for ransom before receiving their money. The fleet sailed for Texas in January 1841.

Upon his return to Galveston, Commodore Moore was greeted with the news that Great Britain had formally recognized the Republic of Texas. Moore wanted to return to sea immediately and continue to pressure Mexico, but during a brief meeting with Lamar, the president decided it would be best to wait and allow Britain to try and negotiate a settlement between Mexico and Texas. However, instead of laying up his ships for repair and discharging most of his seamen as Lamar had first suggested, Moore persuaded the president to keep the navy busy by conducting a survey of the Texas coast. The survey was a complete success, resulting in the first accurate navigation charts of the Gulf of Mexico. With the use of the new charts, shipping losses dropped dramatically and insurance rates fell, providing an unexpected boost to the Texas economy.

Meanwhile, Mexico broke off negotiations, and President Lamar and Secretary of State Samuel A. Roberts became disenchanted with the prospects for peace with the government of Santa Anna. As a result, Lamar launched his ill-fated expedition to Santa Fe and entered into secret

negotiations with Yucatan to form an alliance against Mexico. In 1838, an insurrection began in Yucatan. The rebels were deeply dissatisfied with the dictatorial methods of Santa Anna, and in 1840, the local assembly, like its new Texas ally, declared independence and drafted a constitution based on the Mexican Constitution of 1824.

In September 1841, a deal was struck between Yucatan and Texas whereby Yucatan agreed to pay Texas $8,000 a month for the use of three ships to defend its coastline against Mexican raiding. All proceeds from any prize ships taken in the operation would be shared. Commodore Moore was given command, along with orders to capture Mexican towns and demand ransom payments for their return. In order to enforce payment, Moore was authorized to destroy public works and seize public property. However, speed was of the essence if the operation was to be implemented. Sam Houston had just been reelected president of the republic, and Lamar and Moore feared that if given the opportunity he would cancel the agreement with Yucatan as soon as he was inaugurated.

On December 15, two days after being sworn in as president, Sam Houston issued an order canceling the Yucatan operation, but the order arrived too late. The *Austin*, the *San Antonio* and the *San Bernard* had already set sail for Sisal, Yucatan. Commodore Moore was fully aware that his mission did not have the approval of President Houston. After his departure, he wrote to his good friend General Albert Sydney Johnston that he would most likely be recalled at the earliest opportunity and subjected to vicious political attacks by the supporters of Sam Houston.

When the fleet arrived in Sisal, Moore discovered that Yucatan was in the middle of negotiations with Mexico to end the rebellion. Realizing that an end to the hostilities would threaten the security of Texas, he persuaded the Yucatan officials to keep their agreement with the Texas Navy until they were certain that Mexico, and more importantly, the wily Santa Anna, were sincere about wanting a peaceful settlement. He immediately sent the *San Antonio* back to Texas with a detailed report for President Houston and included an urgent request that the steam schooner *Zavala* be repaired as soon as possible and sent south to reinforce the Texas fleet. Unfortunately, Texas had only a small navy yard and no one with the technical expertise to repair the *Zavala*. It was never sent.

Continuing the operation, Moore captured several Mexican ships before receiving news that convinced him he was following the right course. Word reached the fleet that the Texas prisoners taken as a result of Lamar's Santa Fe expedition were brutally force-marched the entire 1,500 miles to Mexico

City, where the few survivors were thrown into prison. To make matters worse, Santa Anna ordered an incursion into Texas by General Raphael Vasquez that resulted in the brief occupation of San Antonio. Unbeknownst to Moore, President Houston issued orders to maintain the blockade of the Mexican coast, retroactively approving the fleet's actions. Moore continued his depredations of Mexican shipping in and around the vital port of Veracruz until April 1842, when low on money and supplies and with the men's terms of enlistment running out, he sailed for New Orleans.

While in New Orleans tending to the repair and refit of his ships, Commodore Moore received orders to return to Texas. In May, Moore met with President Houston in Galveston, where he learned that Houston planned to withhold the $20,000 Congress had appropriated for the Texas Navy. Moore failed to understand Houston's motives. Publicly, the man called for volunteers to avenge the Santa Fe disaster and the sack of San Antonio by Mexican troops, but privately he appeared to favor a different course. The president rescinded his blockade order just nineteen days after sending it to Moore, and then after telling Moore he wanted him to lead an invasion of Tampico he failed to call Congress into session in time for its approval.

By July, Moore had come to despise Houston's constant wavering. He accused the president of being a "humbug" and considered resigning "in disgust." However, he later wrote that he "still hoped to redeem the enterprise from failure, which was so important to the salvation of my country." Relying on the hope of prize money and help from Yucatan, Moore used his own credit to equip and provision the fleet. While back in New Orleans, Moore received conflicting orders. He was told to sail at once and begin to prey on Mexican shipping, hoping that his actions would force the Mexicans to resume negotiations. He was also told to bring the fleet back to Galveston if he could not find the additional funds necessary to make the ships seaworthy.

While contemplating which course to follow, Moore received word from his friends in Texas that Houston was planning to sell the Texas Navy and that the president had delivered a secret message to Congress accusing the commodore of malfeasance with naval funds. Moore had incurred more than $35,000 in personal debt attempting to keep the fleet at sea, and although he was outraged by Houston's accusations, he still wanted to continue the mission. Once again the government of Yucatan came to Moore's assistance, offering an agreement similar to the one it had made with President Lamar two years previously. For a payment of $8,000 a month, the Texas Navy would break the Mexican blockade and continue to patrol the coast off Yucatan until it was free of Mexican warships.

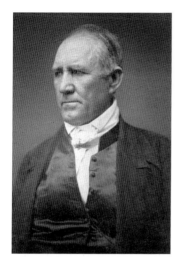

Sam Houston, first president of the Republic of Texas. *Wikimedia Commons.*

Moore quickly provisioned his ships and made ready for sea, gathering men from wherever they could be found, including the local jails and workhouses. By mid-February, the fleet was ready to sail, but before the ships could weigh anchor, two of Houston's commissioners, Colonel James Morgan and William Bryan, arrived with orders to take control of the navy and sell the ships. Stating the he was under an obligation to Yucatan and that his ships were in good repair and ready for action, Moore defied the commissioners and somehow persuaded them to allow him to sail to Galveston and answer President Houston's charges in person. Bryan decided to return to Texas for further instructions, but Colonel Morgan actually joined Moore, writing that the ships were in "apple pie order" and the crews "bully."

The *Austin* and the *Wharton* sailed on April 15, 1843, and with Morgan's concurrence set a course directly for Yucatan, bypassing Texas. On the morning of April 30, the Texas vessels and two Yucatan ships—along with five small gunboats—engaged six Mexican vessels, including the new steamships *Mocteczuma* and *Guadaloupe*. The fighting was hot and heavy, with one broadside after another exchanged throughout the course of the morning, but the battle proved inconclusive. The Mexicans withdrew, but later in the day with the Texans nearing the port of Campeche, the battle resumed. During the heavy fighting that followed, the Texans suffered only two killed and three wounded, while the Mexicans lost twenty-one killed and thirty wounded.

Commodore Moore spent the next two weeks stalking the Mexican steamships and on May 16 engaged them once again. At one point in the battle, Moore sailed the *Austin* between the *Mocteczuma* and the *Guadaloupe*, closing with the Mexicans and raking their decks with several thunderous broadsides of solid shot and canister. The *Austin* was badly damaged in the brawl, with three killed and twenty-one wounded, but the Mexican steamships both suffered serious damage with 183 killed. The Battle of Campeche would go down in history as the only naval victory of sail over steam. Colonel Morgan later landed at Campeche, where he received a letter from President Houston telling him to "by all means have the commodore 'yoked' and manacled, if possible."

Houston had issued a public proclamation on May 6 denouncing Moore and charging him with mutiny, treason and piracy. In the proclamation, Moore was further charged with disobedience and violation of Texas law. In addition, the commodore was suspended from duty and ordered to return to Texas immediately for court-martial. When Morgan reached Moore with the news on June 1, the two men decided to make for home, where they would hold Houston to his word and demand a trial in which the commodore would have an opportunity to explain his actions and clear his good name.

On July 14, Commodore Moore arrived in Galveston to a hero's welcome. As far as the public was concerned, Moore had defended Texas and avoided a potential disaster. The people burned a figure of Houston in effigy during the celebration. Sam Houston was totally unmoved by Moore's public support. The Texas seamen were dismissed, Colonel Morgan was fired as a commissioner and Commodore Moore was dishonorably discharged from the Texas Navy.

After Moore published a two-hundred-page pamphlet documenting his actions, a congressional investigation found that the commodore had been illegally dismissed and was therefore entitled to a court-martial. The trial lasted seventy-two days, and in the end Commodore Moore was convicted of only four minor counts of disobedience. The citizens of Texas considered the verdict a complete vindication of Moore's actions, but Sam Houston angrily vacated the findings of the court.

Chapter 17

THE BATTLE OF WALKER'S CREEK AND THE COLT PATERSON REVOLVER

The Texas Rangers Adopt a New Weapon

The Battle of Walker's Creek was more of a minor skirmish than a battle, but thanks to Samuel Colt, the outcome of the fight had pivotal consequences in the long-running struggle between the Comanches and the Texas Rangers. Given enough men, the rangers were able to dismount and fight the Comanches on foot, keeping them at bay by firing accurate, well-coordinated volleys with their long rifles—some men firing while others reloaded. However, prior to Walker's Creek, the Texans were at a distinct disadvantage when it came to fighting on horseback.

A Comanche warrior on horseback could launch ten or twelve arrows from his powerful short bow in the time it took a ranger to dismount and reload his rifle. And reloading a rifle while mounted was an even slower and more precarious process. Moreover, the accuracy of the bow and arrow in the hands of a mounted warrior was unquestioned, while a ranger firing his percussion rifle or horse pistol from horseback was unlikely to hit anything. Darting in and out and slipping off to the sides of their ponies, the Comanches would tempt the rangers into firing and then charge in for the kill.

During the Battle of Walker's Creek, the Comanches attempted to use their traditional style of mounted warfare, but thanks to Sam Colt, each of the rangers was armed with two rapid-firing Colt Paterson revolvers. A Comanche who took part in the fight complained that the rangers "had a shot for every finger on the hand." The basic idea of a revolving cylinder had been around for a long time, but it took a combination of Samuel Colt's

genius and the emerging technology of percussion caps to bring to life the concept of the first multiple-shot revolver using a percussion cap to ignite a charge of powder that in turn fired a round lead ball from the cylinder.

Sam Colt obtained a patent for a repeating firearm in 1836 and began manufacturing the Colt Paterson model revolver in 1837 in his Paterson, New Jersey workshop. Colt produced several models of the Paterson. Model No. 5 was a five-shot .36-caliber percussion revolver with a nine-inch barrel and a folding trigger that only emerged when the hammer was cocked, a feature common to all Paterson Colts. The revolver was a bit fragile, and the barrel had to be removed to switch cylinders, but the weapon came with an extra cylinder or two, giving the user ten to fifteen shots before it became necessary to reload the cylinders. Colt's model No. 5 was referred to as the "Texas" Paterson because of its use by the Texas Rangers at Walker's Creek.

How the rangers got their hands on the weapon is quite a story. After the United States Army rejected the Paterson as being too impractical because soldiers would be encouraged to waste ammunition with a sidearm that could fire five times without reloading, Sam Colt turned to the new Republic of Texas. In 1838, he sent a pair of the revolvers to President Sam Houston, but the Texas Army rejected the weapon, thinking that the barrel would get too hot to handle and that that "the whole formation [seemed] to be too complicated for use in the field." Then a Washington hotel owner whose son served in the Texas Navy wrote to the secretary of the navy praising the merits of Sam Colt's new revolver, and in 1839, the secretary ordered 160 of the weapons.

The story came full circle when a January 16 act of the Texas Congress authorized Captain Jack Hays to raise a new ranger company of forty privates that was to operate from Bexar County to Refugio County and points west. While meeting with the president to discuss his assignment, Houston told Hays that the soon-to-be-decommissioned Texas Navy had received a shipment of the new Colt five-shooters and that he could place an order with the secretary of war to equip his new company with the revolvers. After personally securing the weapons from a Galveston warehouse, Hays returned to San Antonio and issued each of his new rangers two Colts.

The remainder of the winter of 1844 passed quietly, but after an uneventful spring, word reached San Antonio during the first week in June that a good-sized Comanche war party under the leadership of a war chief named Yellow Wolf was raiding the settlements in the northern and western reaches of Bexar County. In the first week of June 1844, Hays rode out of San Antonio at the head of fourteen rangers, all of them eager to put their new Colts to the test.

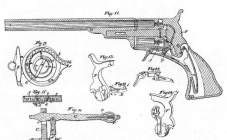

Above: Samuel Colt, inventor of the Colt Paterson revolver. *Wikimedia Commons*.

Left: Colt Paterson patent illustration, 1839. *Wikimedia Commons*.

Texas Rangers monument located outside of the state capitol building in Austin, Texas. *Courtesy of Daniel Mayer, Wikimedia Commons.*

The rangers thoroughly scoured the hills as far as the Pedernales River without discovering any sign of the Comanches and reluctantly turned back, following the Pinta Trail to the ford on the Guadalupe River in the area of present-day Kendall County. There they set up camp near Walker's Creek. One of the rangers, Noah Cherry, spotted a bee tree and was halfway up to seize his prize when he called out, "Jerusalem, captain! Yonder comes a thousand Indians!"

Private Cherry scrambled back down the trunk of the bee tree, quickly joining the other rangers as they saddled up and mounted. The war party, numbering between seventy and eighty warriors, withdrew to some wooded

terrain. Hays got the rangers on line and advanced to within a few hundred yards of the woods when fifteen or twenty warriors rode out into the clear and began to badger them for a fight. The remainder of the war party remained in the cover of the woods. Hays had too much experience dealing with Comanches to fall into such an obvious trap, and he waited patiently until the entire war party emerged from the trees and formed a line of battle. A dry ravine ran to the rear of the Comanche line, and beyond the ravine rose a high, timber- and brush-covered hill strewn with rocks. Hays gave the signal for his rangers to advance at the trot, and the Comanches fell back through the ravine and took cover on the hill.

From behind the rocks and trees, the warriors taunted the rangers in Spanish, hoping to lure them into making a frontal assault on the formidable defensive position. However, instead of launching an attack, Captain Hays cleverly used the cover of the dry ravine to move his rangers around the hill and come up behind the Comanches. After quickly forming his men into a wedge, Hays charged the rear of the Indian line. Ben McCulloch, a veteran ranger and Hays's second in command, later wrote that the fight for the top of the hill was hand-to-hand and that "they took it rough and tumble." Fighting fiercely although heavily outnumbered, the rangers drove off two counterattacks on their flanks with the firepower of the Colt Patersons before the Comanches finally fled the field.

Captain Hays led the pursuit for three miles, making sure his rangers kept the warriors under heavy fire with their revolvers. "Crowd them! Powder-burn them!" were Hays's shouted orders. During the three-mile, hour-long Comanche retreat, Yellow Wolf rallied his warriors for three separate counterattacks. The rangers fought in relays, one group quickly switching the cylinders of their Colts while the other engaged the Comanches. Just as Yellow Wolf was haranguing his warriors into making one more attack, ranger Ad Gillespie shot him in the head at thirty yards. Now thoroughly demoralized, the Comanches fled the field.

In the intense struggle, Hays estimated the Comanche casualties from twenty to more than fifty wounded or killed, including Yellow Wolf. One ranger was killed and four seriously wounded. Among the latter was Sam Walker, his body pierced by the thrust of a Comanche war lance. Although not expected to live, Walker survived to become a national hero during the Mexican-American War and the co-designer, along with Sam Colt, of the famous Walker Colt revolver.

The Battle of Walker's Creek, also known as the Battle of Pinta Trail Crossing, the Battle of Asta's Creek and the Battle of Sisters Creek, was

Statue of John Coffee "Jack" Hays and the Colt Patterson revolver. *Photo courtesy of Jeffery Robenalt, February 2011.*

characterized by the *Houston Morning Star* as "unparalleled in this country for the gallantry displayed on both sides, its close and deadly struggle, and the triumphant success of the gallant partisan captain of the west." Walker's Creek marked the first time that an entire company of Texas Rangers armed with Colt revolvers participated in combat.

Jack Hays later attributed the victory solely to the Patersons. The weapons were so deadly that the rangers fired only 150 shots during the entire engagement. Later models of the Colt Paterson revolver were adorned with an engraving of the battle scene on the cylinder. The engraving, based on a sketch by Sam Walker, shows Texas Rangers chasing Comanches with Jack Hays mounted on a white horse and Sam Walker mounted on a black one. The Colt Paterson revolver caused a revolution on the Texas frontier, as the pendulum of warfare slowly swung in favor of the rangers. While Sam Colt was the inventor of the five-shot and later six-shot repeating revolvers, the rangers were certainly responsible for discovering their utility. Mounted warfare between the Comanches and the Texas Rangers would never be the same.

Chapter 18

LAND POLICY OF THE REPUBLIC AND FOREIGN SETTLEMENT

A German Prince on the Frontier

The Republic of Texas emerged from the revolution buried in debt and with practically no assets, save for its vigorous population and vast, unsettled public lands. Yet in spite of the problems, a wave of optimism swept the new country. The people of Texas were suddenly free to establish their own institutions, to make the most of every opportunity that presented itself and free to form their own government based on American—not Mexican—ideals and traditions. Moreover, with an end to Mexican immigration barriers, a rising tide of new settlers would soon pour into the Lone Star Republic to assist in the task of building a new nation.

The primary problem facing the citizens of the republic was how to finance the government they had just created, let alone pay off the debts that had accrued during the revolution. Unfortunately, most citizens were so cash-poor they had to get by chiefly on barter, and paying taxes was out of the question. Customs duties on imported goods brought in some hard cash, but it was so little that even the Texas Army had to be disbanded in favor of an inexpensive militia system. Like the Congress of the United States, the Texas Congress hoped to eventually finance the Texas government by selling public land to homesteaders, but before the republic could hope to compete with their wealthy northern neighbor, potential settlers would have to be offered a much better deal.

The bargain that the Republic of Texas eventually offered was unprecedented: a huge grant of absolutely free land for all new settlers. Each family was given an incredible 1,280 acres (two square miles), and each

unmarried man received 640 acres. The amount of free land was gradually reduced over the years, and after 1844 all new settlers received 320 acres whether married or single—still twice the land a settler could hope for in the United States. With the advent of the land giveaway, the population boomed. In 1838, the Houston *Telegraph and Texas Register* reported, "A gentleman who lately arrived from Bastrop County states that immense numbers of immigrants are constantly arriving in the section," and the *Matagorda Bulletin* related that "the Colorado River, up to the base of the mountains, is alive with the opening of new plantations, and towns and villages seem to be springing up spontaneously along its banks."

Most of the newcomers who poured into the republic were southerners from the United States. Included in their ranks were well-to-do land speculators, slave-owning planters and merchants whose sound American dollars would stretch a lot further in Texas than back in the states. They were joined by much-needed blacksmiths, carpenters, millers and other craftsmen eager to take up the offer of a free town lot in addition to their land grants. However, as always, the majority of the new settlers were frontier farmers—the hardy, restless, stubborn brand of independent men whose only answer to being crowded in by new neighbors was to continually move west.

Packing only necessary possessions and perhaps a few rare items they deemed precious into a wagon (two if they were fortunate) the land-hungry immigrants plodded southwest over roads that were no more than deep wagon ruts—swampy quagmires during the spring rains and buried in choking clouds of dust in late summer. Usually armed with a letter from a friend or relative who had come to Texas before them, the majority of settlers arrived with a general idea of where they intended to settle. The first step upon reaching their destination was to appear before a board of county commissioners. From the board, the settler received a certificate authorizing him to select his land entitlement from anywhere in the public domain. With so many prime locations available, many newcomers found the choice difficult, but once a site was selected, the settler had only to get the land surveyed and send a description of the boundaries and his land certificate to the capital. The General Land Office would then issue a title.

The simplicity of the entire process led to an ongoing market in transferable land certificates. Some settlers sold their certificates to speculators as soon as they were issued and then squatted on public land. Some were unable to work their entire grant, so they filed on only a portion of the land and received a title and a remainder certificate, which could then be used to claim the remaining land at a later date or immediately sold to a

speculator. As a consequence of the republic's desperate money policy, much of the land passed through the hands of at least one speculator before it was settled. Since there was no gold or silver to guarantee the currency, the Texas government issued paper scrip backed by public land. The currency could then be redeemed upon demand at the rate of one acre for each fifty cents of face value.

Not all settlers immigrated to Texas from the United States or followed the same path to land ownership. Many of the newcomers were European, most of them German, but smaller groups also emigrated from France, England, Ireland and other European countries. Substantial, well-educated Germans who were seeking personal freedom and business opportunities dominated this migration. The old empresarial system was adopted in 1841 to attract foreign immigrants to Texas. Among the new empresarios were Frenchman Henri Castro and German partners Henry Fisher and Burchard Miller.

Henri Castro, a man of scholarship and exceedingly great energy, was granted a contract in February 1842 to settle six hundred families or single men on 1.25 million acres of land west of San Antonio near the Medina River. Between 1843 and 1847, Castro chartered twenty-seven ships to bring a total of 2,134 German-speaking Alsatian farmers and fruit growers from France, establishing his first colony at Castroville in September 1844. Subsequently, Castro founded the village of Quihi in 1845, the town of Vandenberg in 1846 and the village of D'Hanis in 1847. Much like Stephen F. Austin, the original Texas empresario, Castro established a successful colony without significant financial gain for himself. Investing $200,000 of his own money for the good of his people, he furnished them with livestock, tools, planting seed, medicines and whatever else they needed.

Although Castro was a generous, learned man with unbounded faith in the capacity of intelligent men to be fair and able to self-govern, his faith was not returned in kind by his colonists. The new immigrants agreed to give Castro half their land grants in payment for all the funds he expended in establishing the colony; however, when a land commissioner arrived in 1850 to issue titles, the colonists reneged on their agreement and refused to give him the land they had promised. As a result of this deception, Castro issued only 299,846 acres of land—less than 10 percent of the amount his empresarial contract had permitted him to settle. After a long and fruitful life dedicated to Texas and the growth of the colonies he established, Henri Castro died in Monterrey, Mexico, in 1865 on his way to visit France.

Henry Fisher and Burchard Miller were also granted an empresarial contract in 1842 to settle six hundred German, Swiss, Norwegian,

Monument to Henri Castro, Castroville, Texas. *Courtesy of Billy Hathorn, Wikimedia Commons.*

Swedish and Danish families on 3 million acres located between the Llano and Colorado Rivers. The contract was modified in 1844 to permit six thousand families or single men to apply for grants. That same year, Fisher arrived in Germany and met with officials of the Society for the Protection of German Immigrants in Texas. The society, founded by twenty-five German noblemen and headed by Prince Carl of Solms-Braunfels, planned to channel all German immigration to Texas into one cohesive German colony. The noblemen, who raised $80,000 for the project, believed their efforts would provide homes for deserving German workers, establish markets for German-manufactured goods and develop a trade network between Germany and Texas.

The society planned to charge each family $240 in exchange for 320 acres, ship passage to Texas, a house, farm tools and enough supplies to last until the first harvest. In June 1844, the noblemen of the society purchased a 4-million-acre tract from Henry Fisher for $9,000 that Fisher described as "ideal for their purposes." Unfortunately, when Prince Carl arrived in Texas to ease the path for the initial migration of German colonists, he

discovered that Fisher had misrepresented his empresarial grant. Instead of lying near the Gulf Coast, the grant was 250 miles inland. Not only was the grant too isolated for convenient trade or easy colonization, but it was also was situated on land that was controlled by the fierce war-like Comanches. The first wave of 439 German immigrants arrived at Matagorda Bay in December without a destination.

Not a man to be daunted by such hardship, Prince Carl left the settlers well taken care of, with unlimited credit to draw against the society's funds, and set off to locate a tract of land suitable for colonization that could serve as a halfway station between the coast and the original proposed colony. By the time the prince purchased a nine-thousand-acre tract for $1,111 in March 1845, located twenty-nine miles northeast of San Antonio, the society's funds were nearly depleted. Prince Carl named the site New Braunfels after his German estate and settled the colonists in late April. The land was rich and promising, and the settlers immediately set to work building homes and a protective fort; however, by the time they were finished, they deemed it too late in the season to plant crops. Prince Carl, unconcerned that the colonists expected to be fed for another year, regarded his mission as accomplished and returned to Germany.

John O. Meusebach, the former Baron von Meusebach, had the unfortunate responsibility of stepping into Prince Carl's shoes. Meusebach was shocked when he learned that the society's funds were exhausted and another four thousand colonists were due to arrive in December. In response to Meusebach's urgent request, the society provided an additional $60,000, and the former baron managed to settle not only the four thousand newcomers but also three thousand more. Pushing eighty miles northwest, Meusebach founded the town of Fredericksburg in 1845 and the village of Castell on the original Fisher grant in 1847. The society eventually declared bankruptcy, but Meusebach remained in Texas to live out his life as a respected farmer and legislator. Prince Carl may not have been totally successful in his efforts, but he began a floodtide of immigration that ultimately brought thirty-five thousand German settlers to Texas, making them second in population only to the Anglo-Americans.

In spite of the hardships, the Texas frontier continued to march west into the dangers of the Comancheria in an uncharted but logical pattern. Behind the westward movement, the towns and settlements increased in size and number. They also changed in character—from simple supply centers established to support the farmers to commercial centers that developed the excitement and variety of city life. The Texans may well have shaped the

Statue of John O. Meusebach and a Comanche chief at Fredericksburg, Texas. *Photo courtesy of Kevin Braeutigam.*

land, but the land also helped to shape the Texans. The steady advance west left considerable distances between settlements, and the size of the landholdings left expansive distances between neighbors. These conditions forged the Texas character. Isolation built self-reliance and an appreciation for neighbors that were seldom seen, while braving solitude as well as the constant threat of Indian attacks made most Texans self-willed in the extreme, impatient with unnecessary laws and resistant to any restraints on their freedom.

Chapter 19

THE STRUGGLE FOR ANNEXATION

The Republic Joins the Union

When Texans elected Sam Houston as the first president of the republic in September 1836, most citizens also cast their ballots in favor of immediately seeking annexation to the United States. Joining the Union made perfect sense to the majority of Texans—and why not? Many had emigrated from the United States, and their language, customs, values and views of law and government were nearly identical to those of Americans. The annexation of Texas would also benefit the United States by promoting westward expansion and fulfilling the promise of Manifest Destiny. In light of all that weighed in favor of annexation, Texans were convinced that the United States would be eager to accept Texas as a new state. Therefore, they were shocked and disappointed when President Andrew Jackson, a man regarded by most Texans as their best friend in America, not only failed to seek annexation of the republic but also refused to extend recognition to the new government.

Although Andrew Jackson was personally in favor of recognition, he had sound reasons for delaying any formal action on the part of the United States. A move toward recognition of the republic before Mexico had accepted Texas independence could be construed as an unfriendly act or, worse, drag the United States into a war south of the Rio Grande. An even greater obstacle to Texas recognition was the question of slavery. The majority of Texans had originally come to Texas from southern states, and many of them had either brought slaves or the tradition of slavery along with them. At the dawn of the republic, there were more than three

President Andrew Jackson. *Wikimedia Commons.*

thousand slaves planting, harvesting and ginning cotton, the only real cash crop grown in Texas. If the republic did join the Union, it would surely come in as a slave state.

Led by the more uncompromising abolitionists, the antislavery movement in the United States was growing stronger every day, and the idea of adding a new slave state to the Union was becoming unacceptable to an increasing number of northerners. Most abolitionists thought of recognition as the first step toward annexation, and they fought it with a passion. To make matters even more difficult, President Jackson had the upcoming election of his good friend and vice president Martin Van Buren to consider. If Jackson

ventured too far toward recognition before the election, Van Buren would lose northern votes and perhaps the presidency. Jackson's only choice was to wait, and if he waited, so too would Texas.

How important was recognition for the Republic of Texas? Without formal recognition as a nation by other nations, Texas would be forced to stand apart from the world community. Titles to Texas land grants would have no value, thus crippling efforts to attract new settlers, and Texas currency and bonds would be worthless outside of its borders. There would also be no hope of attracting foreign investment or signing formal treaties of commerce and cooperation with other nations. However, no matter how important recognition was to the new republic, no nation would be willing to recognize Texas until the United States had committed itself.

Texas ministers to Washington J. Pinkney Henderson and William Wharton continued to lobby behind the scenes for recognition, and the prospects improved when Martin Van Buren won the 1836 election. Now lame-duck president Andrew Jackson was free to act. On March 3, 1837, the final day of his presidency, Jackson extended formal recognition to the Republic of Texas. France ultimately followed the lead of the United States, formally granting recognition to the republic on September 25, 1839, but the United Kingdom refused to grant formal recognition because of its friendly relations with Mexico. However, the republic's admission to the Union was an entirely different matter. Nothing had been done to erase the problems of slavery and the hostile relations with Mexico, and they hung like a dark cloud over the issue of annexation. President Van Buren refused to even consider the question, and the delegation from Texas, led by Anson Jones, reluctantly turned to Congress.

After many days of intense lobbying, several members of Congress who favored annexation finally agreed to introduce a bill to admit Texas. Unfortunately, John Quincy Adams, former United States president and present member of Congress, blocked passage of the bill. A devout abolitionist, Adams was determined not to admit any state that favored slavery to the Union. It was a view shared by many other legislators. Adams continued to drag his heels until Sam Houston, embarrassed for Texas by the long delay, ordered Jones to withdraw the request for annexation. With the possibility of annexation closed, it became necessary to seek strong friends in Europe for the purposes of establishing trade, selling bonds and securing further recognition. Houston sent J. Pinkney Henderson to England and France for this purpose. It was one of his last efforts as president of Texas.

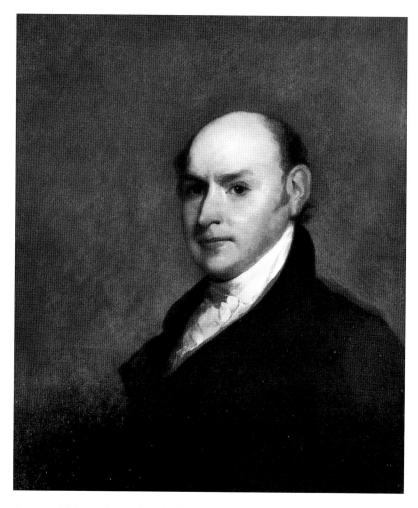

Portrait of John Quincy Adams by Gilbert Stuart, 1818. *Wikimedia Commons.*

The Texas Constitution limited the first president to a term of two years. Later presidents would serve for three years; however, no president was permitted to serve consecutive terms. Mirabeau Lamar, whose distinguished record as a poet, publisher and hero at the Battle of San Jacinto made him an ideal candidate, was elected the second president of the republic in 1838. Unlike Houston, Lamar favored a Texas that was not under the influence of the United States—a country free to go its own way and eventually expand all the way to California and the Pacific Ocean. Such a view left no room for the possibility of annexation, and for the next three years, the policy

became a forgotten issue, until Sam Houston once again ran for and won the presidency in 1841.

Lamar's administration had left the republic in dire straits. Hope of peaceful coexistence with Mexico had vanished, Texas currency had fallen to three cents on the U.S. dollar and the public debt topped $6 million. In his second inaugural address on December 13, 1841, Sam Houston appeared in a homespun linsey-woolsey shirt and said, "There is not a dollar in the treasury. We are not only without money but without credit and for want of punctuality, without honor." To address the problems, Houston cut government expenses to the bone, including his own salary; dismissed the regular army; sold the navy; and urged peace with Mexico. "The true interest of Texas," he declared, "is to maintain peace with all nations and cultivate the soil." Although these measures helped, Houston knew the only lasting solution was to again seek annexation.

During the latter stages of Houston's second term, annexation became a distinct possibility. John Tyler assumed the office of president of the United States following the death of William Henry Harrison. John C. Calhoun, Tyler's secretary of state, negotiated a treaty with J. Pinkney Henderson in April 1844 whereby the United States would admit Texas as a territory, take possession of Texas's public lands and assume the republic's debt. Most Texans preferred statehood immediately upon annexation, not territorial status, but they reluctantly agreed to accept the terms of the treaty. Unfortunately, the vote in the U.S. Senate fell woefully short of the two-thirds approval that was required. Houston was disappointed, but the attempt at annexation had again brought the issue to prominence, and it became a key factor in the U.S. presidential campaign later in the year.

In the Texas presidential election of 1844, voters opted for the experienced diplomat Dr. Anson Jones over the veteran soldier Edward Burleson. Meanwhile, in the United States, two leading presidential candidates—former president Martin Van Buren, the Free-Soil candidate, and Henry Clay, the Whig Party nominee—failed to address the issue of annexation during their campaigns. The Democrats, who called for the annexation of Texas as part of their party platform, nominated James K. Polk of Tennessee. Polk, who campaigned vigorously on behalf of Texas annexation, won the election. Lame-duck President Tyler interpreted Polk's victory as a clear mandate for annexation, and instead of waiting for Polk to assume office, he recommended that Congress annex Texas by joint resolution, a procedure that required only a simple majority of both legislative houses—not two-thirds of the Senate.

"Texas Coming In." A pro-Democrat political cartoon satirizing the fall of Whig opposition to the annexation of Texas to the United States. *Courtesy of Library of Congress.*

Statue of Anson Jones at Jones County, Texas. *Courtesy of Billy Hathorn, Wikimedia Commons.*

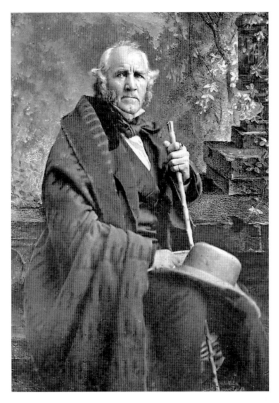

Portrait of Sam Houston by Mathew Brady, 1861.
Wikimedia Commons.

The joint resolution passed, and President Tyler signed it on March 1, 1845, two days before he left office. The terms of the resolution were much more favorable to Texas than the treaty that had been previously presented by Secretary Calhoun. Texas would join the Union as a state and retain possession of its public lands, but its debt would not be assumed by the United States. The United States would also take the lead in dealing with Mexico. A special convention, assembled in Austin on July 4, 1845, drafted a state constitution and adopted the joint resolution with only one dissenting vote. On October 13, both the constitution and annexation were approved by an overwhelming majority of Texas voters. The Texas Admission Act was signed into law by President Polk on December 29, 1845, and the formal ceremony took place in Austin on February 19, 1846.

Ironically, with the election of Anson Jones, Sam Houston, who had labored so diligently for annexation, played little part in the final negotiations or formalities. During the formal ceremony, President Jones turned the reins of government over to the state's new governor, J. Pinkney Henderson, and ordered the Lone Star Flag of the republic to be lowered for the last time. "The final act in this great drama is now performed," he stated. "The Republic of Texas is no more." As the flag was slowly lowered, Sam Houston stepped forward and lovingly took the symbol of the republic into his hands.

BIBLIOGRAPHY

Allen, O. Fisher. *The City of Houston from Wilderness to Wonder*. Temple, TX: self-published, 1936.

Barker, Eugene C. *The Life of Stephen F. Austin, Founder of Texas, 1793–1836: A Chapter of the Westward Movement by the Anglo-American People*. Cambridge, MA: Da Capo Press, 1968.

Barr, Alwyn. *Black Texans: A History of African Americans in Texas, 1528–1995*. Norman: University of Oklahoma Press, 1996.

———. *Texans in Revolt: The Battle for San Antonio, 1835*. Austin: University of Texas Press, 1990.

Biesele, Rudloph Leopold. *The History of German Settlements in Texas, 1831–1861*. Austin, TX: Eakin Press, 1998.

Binkley, William C. *The Texas Revolution*. Baton Rouge: Louisiana State University Press, 1952.

Bradle, William R. Goliad: *The Other Alamo*. Gretna, LA: Pelican Publishing, 2007.

Brice, Donaly E. *The Great Comanche Raid*. Austin, TX: Eakin Press, 1987.

Cantrell, Gregg. *Stephen F. Austin: Empresario of Texas*. New Haven, CT: Yale University Press, 1999.

Castaneda, Carlos. *The Mexican Side of the Texas Revolution*. N.p.: P.L. Turner Company, 1928.

Clarke, Mary Whatley. *Chief Bowles and the Texas Cherokees*. Norman: University of Oklahoma Press, 1971.

Davis, Joe Tom. *Legendary Texians*. Vol. I. Austin, TX: Eakin Press, 1982.

———. *Legendary Texians*. Vol. IV. Austin, TX: Eakin Press, 1989.

Davis, William C. *Lone Star Rising: The Revolutionary Birth of the Texas Republic*. College Station: Texas A&M University Press, 2006.

Edmondson, J.R. *The Alamo Story: From Early History to Current Conflicts*. Plano, TX: Republic of Texas Press, 2000.

Ericson, Joe E. *The Nacogdoches Story: An Informal History*. Bowie, MD: Heritage Books, 2000.

Everett, Dianna. *The Texas Cherokees: A People Between Two Fires, 1819–1840*. Norman: University of Oklahoma Press, 1990.

Fehrenbach, T.R. *Comanches: The Destruction of a People*. New York: Knopf, 1974.

———. *Lone Star: A History of Texas and the Texans*. Cambridge, MA: De Capo Press, 1968.

Fort Tours. "Chief Bowles and the Battle of the Neches." http://www.forttours. com/pages/chiefbowles.asp.

———. "Colonel John H. Moore and His Men, 1839 Fight." http://www.forttours. com/pages/moorebesiege.asp.

Fowler, Mike, and Jack Maguire. *The Capitol Story: Statehouse in Texas*. Austin, TX: Eakin Press, 1988.

Fowler, Will. *Santa Anna of Mexico*. Lincoln: University of Nebraska Press, 2007.

Groneman, Bill. *Battlefields of Texas*. Plano: Republic of Texas Press, 1998.

Haley, James L. *Sam Houston*. Norman: University of Oklahoma Press, 2002.

Hardin, Stephen L. *Texian Iliad: A Military History of the Texas Revolution, 1835–1836*. Austin: University of Texas Press, 1994.

Henson, Margaret Swett. *Juan Davis Bradburn: A Reappraisal of the Mexican Commander of Anahuac*. College Station: Texas A&M University Press, 1982.

Hopewell, Clifford. *James Bowie: Texas Fighting Man*. Austin, TX: Eakin Press, 1994.

———. *Remember Goliad: Their Silent Tents*. Austin, TX: Eakin Press, 1998.

Houston, Sam. "Sam Houston to the Texas Congress, Inaugural Address, October 22, 1836." Speeches of Sam Houston, 1836–38. Texas State Library and Archives Commission.

Jenkins, John Holland. *Recollections of Early Texas: The Memoirs of John Holland Jenkins*. Austin: University of Texas Press, 1958.

Jones, Anson. *Memoranda and Official Correspondence Relating to the Republic of Texas, Its History and Annexation*. N.p.: Rio Grande Press, 1966.

King, Irene Marschall. *John O. Meusebach*. Austin: University of Texas Press, 1967.

Knowles, Thomas W. *They Rode for the Lone Star: The Saga of the Texas Rangers*. Dallas, TX: Taylor Publishing Co., 1999.

Lack, Paul D. *The Texas Revolutionary Experience: A Political and Social History, 1835–1836*. College Station: Texas A&M University Press, 1992.

Lord, Walter. *A Time to Stand*. Lincoln: University of Nebraska Press, 1978.

Maher, Ramona, and Stephen Gammell. *The Glory Horse: A Story of the Battle of San Jacinto and Texas in 1836*. New York: Coward, McCann & Geoghegan, 1974.

Maverick, Mary A. *Memoirs of Mary A. Maverick*. San Antonio, TX, 1921.

Meed, Douglas. *The Fighting Texas Navy, 1832–1843*. Plano: Republic of Texas Press, 2001.

Moore, Stephen L. *Eighteen Minutes: The Battle of San Jacinto and the Texas Independence Campaign*. Dallas: Republic of Texas Press, 2004.

Pruett, Jakie L., and Everett B. Cole. *Goliad Massacre: A Tragedy of the Texas Revolution*. Austin, TX: Eakin Press, 1985.

Ramsay, Jack C. *Thunder Beyond the Brazos: Mirabeau B. Lamar, A Biography*. Austin, TX: Eakin Press, 1985.

Richardson, Rupert N., and Adrian Anderson. *Texas: The Lone Star State*. N.p.: Pearson, 2009.

Roell, Craig H. *Remember Goliad!: A History of La Bahía*. Austin: Texas State Historical Association, 1994.

Schmitz, Joseph William. *Daily Life in the Republic of Texas*. Ingleside, TX: Copano Bay Press, 2007.

———. *Texas Culture: In the Days of the Republic, 1836–1846*. San Antonio, TX: Naylor Company Publishing, 1960.

Scott, Robert. *After the Alamo*. Plano: Republic of Texas Press, 2000.

Siegel, Stanley. *The Poet President of Texas: The Life of Mirabeau B. Lamar, President of the Republic of Texas*. Austin, TX: Jenkins Publishing, 1977.

Texas Almanac. "The Capitals of Texas." http://www.texasalmanac.com/topics/history/capitals-texas.

Texas Military Forces Museum. "The Texas Navy." http://www.texasmilitaryforcesmuseum.org/articles/texasnavy/texasnavy.htm.

Texas State Historical Association (TSHA). "Allen, Augustus Chapman." http://www.tshaonline.org/handbook/online/articles/fal17.

———. "Anahuac Disturbances." http://www.tshaonline.org/handbook/online/articles/jca01.

———. "Archive War." http://www.tshaonline.org/handbook/online/articles/mqa02.

———. "Austin, Stephen Fuller." http://www.tshaonline.org/handbook/online/articles/fau14.

———. "Bexar, Siege of." http://www.tshaonline.org/handbook/online/articles/qeb01.

———. "Bowie, James." http://www.tshaonline.org/handbook/online/articles/fbo45.

———. "Bowl." http://www.tshaonline.org/handbook/online/articles/fbo47.

———. "Capitals." http://www.tshaonline.org/handbook/online/articles/mzc01.

———. "Castro, Henri." http://www.tshaonline.org/handbook/online/articles/fca93.

———. "Constitution of the Republic of Texas." http://www.tshaonline.org/handbook/online/articles/mhc01.

———. "Consultation." http://www.tshaonline.org/handbook/online/articles/mjc08.

———. "Convention of 1832." http://www.tshaonline.org/handbook/online/articles/mjc09.

———. "Goliad Massacre." http://www.tshaonline.org/handbook/online/articles/qeg02.

———. "Houston, Samuel." http://www.tshaonline.org/handbook/online/articles/fho73.

———. "Lamar, Mirabeau Buonaparte." http://www.tshaonline.org/handbook/online/articles/fla15.

———. "Meusebach, John O." http://www.tshaonline.org/handbook/online/articles/fme33.

———. "Moore, Edwin Ward." http://www.tshaonline.org/handbook/online/articles/fmo24.

———. "Neches, Battle of the." http://www.tshaonline.org/handbook/online/articles/qen02.

———. "Public Lands." http://www.tshaonline.org/handbook/online/articles/gzp02.

———. "San Jacinto, Battle of." http://www.tshaonline.org/handbook/online/articles/qes04.

———. "Solms-Braunfels, Prince Carl of." http://www.tshaonline.org/handbook/online/articles/fso03.

———. "Texan Santa Fe Expedition." http://www.tshaonline.org/handbook/online/articles/qyt03.

———. "Treaties of Velasco." http://www.tshaonline.org/handbook/online/articles/mgt05.

———. "Turtle Bayou Resolutions." http://www.tshaonline.org/handbook/online/articles/mht01.

———. "Velasco, Battle of." http://www.tshaonline.org/handbook/online/articles/qfv01.

———. "Waller, Edwin." http://www.tshaonline.org/handbook/online/articles/fwa38.

Texas State Library and Archives Commission. "Mirabeau B. Lamar." https://www.tsl.state.tx.us/treasures/giants/lamar/lamar-01.html.

———. "Stephen F. Austin." https://www.tsl.state.tx.us/treasures/giants/austin/austin-01.html.

———. "The Trial of Edwin W. Moore." http://link.tsl.state.tx.us/exhibits/navy/moore.html.

Todish, Timothy J., Terry Todish and Ted Spring. *Alamo Sourcebook, 1836: A Comprehensive Guide to the Alamo and the Texas Revolution*. Austin, TX: Eakin Press, 1998.

United States Navy Department. "The Texas Navy." Washington, D.C., 1968.

Wallace, Ernest, and E. Adamson Hoebel. *The Comanches: Lords of the South Plains*. Norman: University of Oklahoma Press, 1987.

Webb, Walter Prescott. *The Texas Rangers: A Century of Frontier Defense*. Austin: University of Texas Press, 1965.

Weber, David J. *The Mexican Frontier, 1821–1846: The American Southwest under Mexico*. Albuquerque: University of New Mexico Press, 1982.

Wells, Tom Henderson. *Commodore Moore and the Texas Navy*. Austin: University of Texas Press, 1960.

Winders, Richard Bruce. *Sacrificed at the Alamo: Tragedy and Triumph in the Texas Revolution*. Abilene, TX: State House Press, 2004.

INDEX

ABOUT THE AUTHOR

Jeffery Robenalt was born in Tiffin, Ohio, and graduated from Columbian High School in 1965. He served as a U.S. Marine Corps helicopter crew chief in Vietnam and later served in the U.S. Army as a platoon leader and executive officer with Company C, 1-506th Infantry, 101st Airborne Division. Mr. Robenalt earned a BS in sociology from Troy University, a BA in history from New York University and a doctor of jurisprudence in law from Texas Tech University. After completing his studies, Mr. Robenalt served as an attorney for the State of Texas for ten years. He currently resides with his wife, Lizabeth, and daughter, Emily, in Lockhart, Texas, where he teaches Texas history at Lockhart Junior High School. Mr. Robenalt has also written three historical fiction novels—*Saga of a Texas Ranger*, *Star Over Texas* and *The Bloody Frontier*—and writes a historical column on Texas history for *Texas Escapes Online Magazine*, also entitled "A Glimpse of Texas Past." Read more about Jeff at his website: sagaofatexasranger.com.

Visit us at
www.historypress.net

This title is also available as an e-book